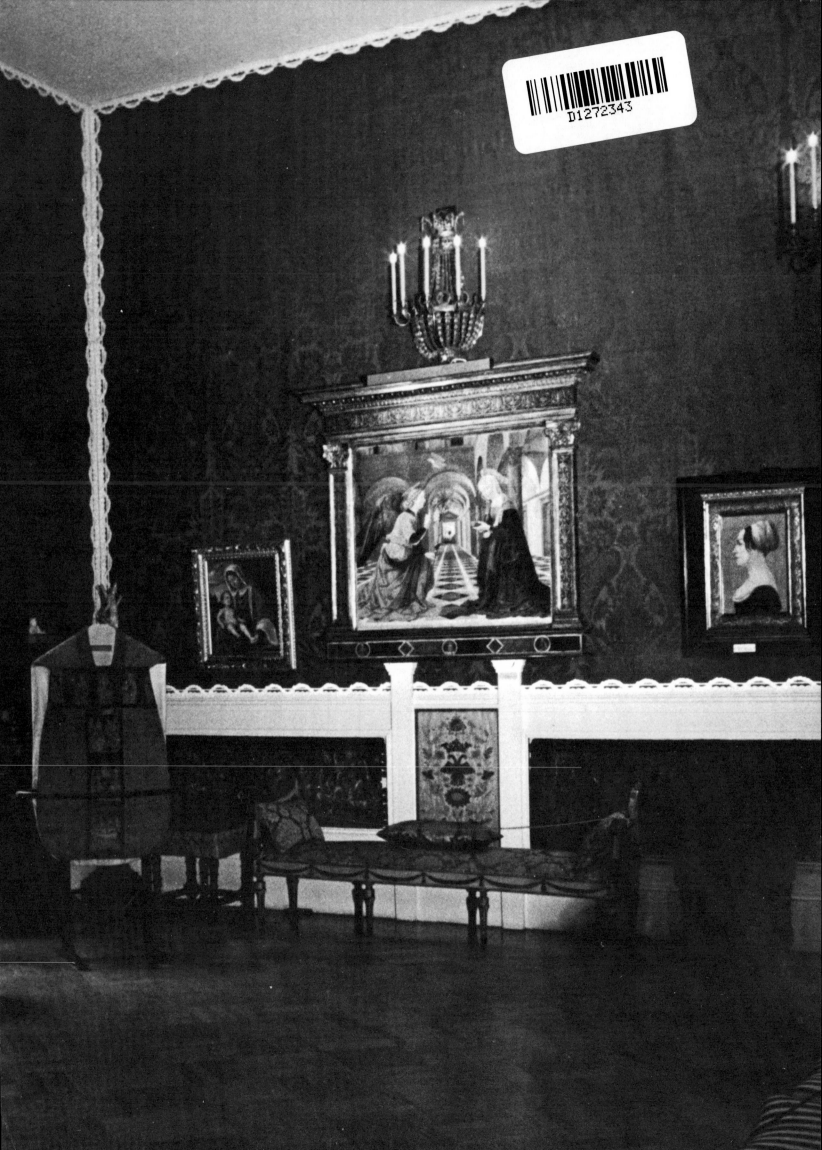

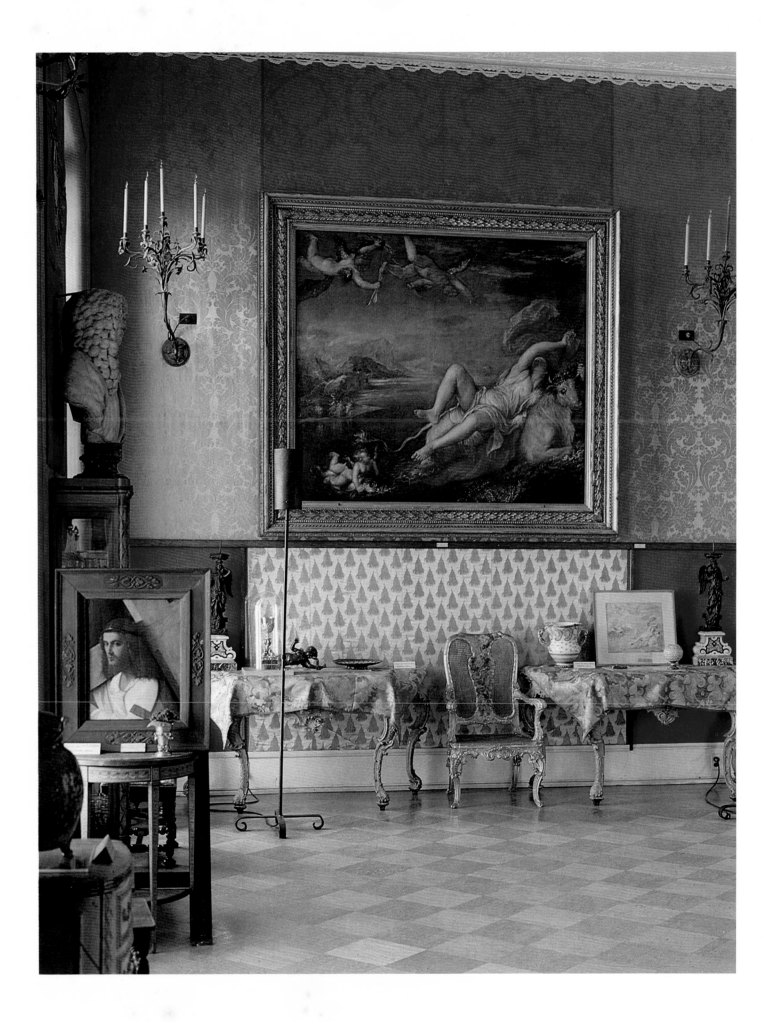

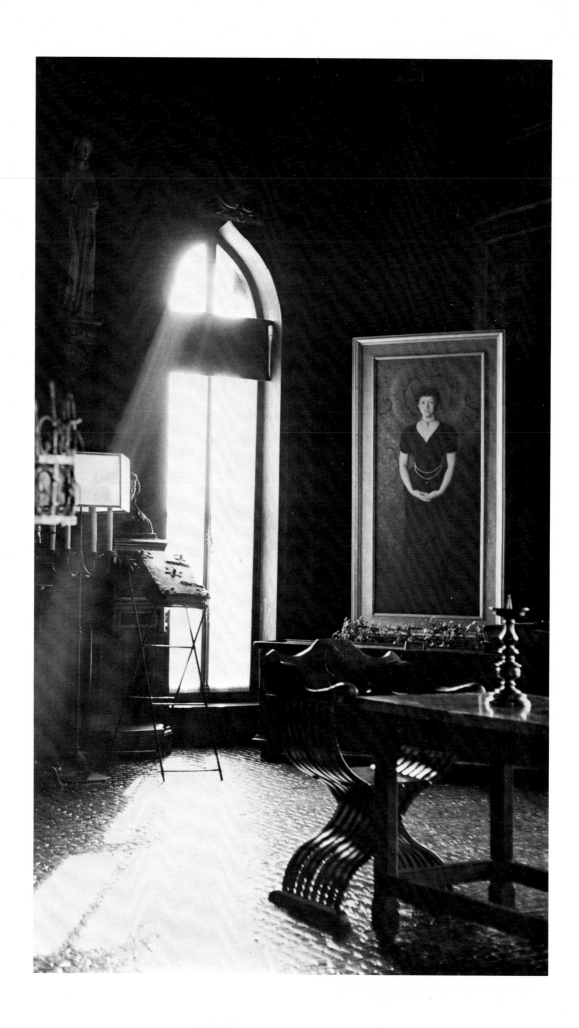

The Isabella Stewart Gardner Museum

PUBLISHED BY THE TRUSTEES

BOSTON 1978

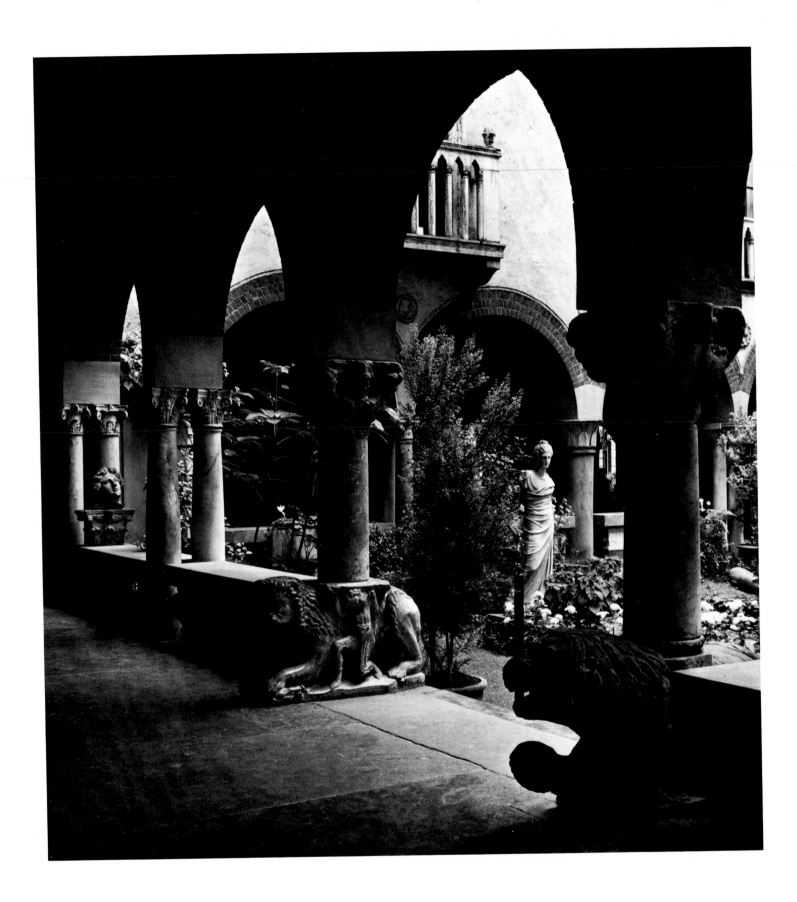

Contents

COVER: Carlo Crivelli (active 1457-c. 1493). *Saint George and the Dragon*, detail, tempera on wood. *Photograph: Herbert Vose.*

FRONT ENDLEAF: The Raphael Room. *Photograph: Larry Webster.*

FRONTISPIECE: The Titian Room. *Photograph: Joseph Pratt.*

OPPOSITE TITLE PAGE: The Gothic Room. *Photograph: Barney Burstein.*

OPPOSITE TABLE OF CONTENTS: The North Cloister. *Photograph: Larry Webster.*

OPPOSITE PAGE 80: The Courtyard from the third floor. *Photograph: Larry Webster.*

BACK ENDLEAF: The Monks' Garden. *Photograph: Larry Webster.*

Library of Congress Catalogue No: 78-61640

ISBN: 0-914660-05-5
Printed in Great Britain

Reprinted from *The Connoisseur*, May 1978.
© 1978. THE NATIONAL MAGAZINE COMPANY LIMITED.

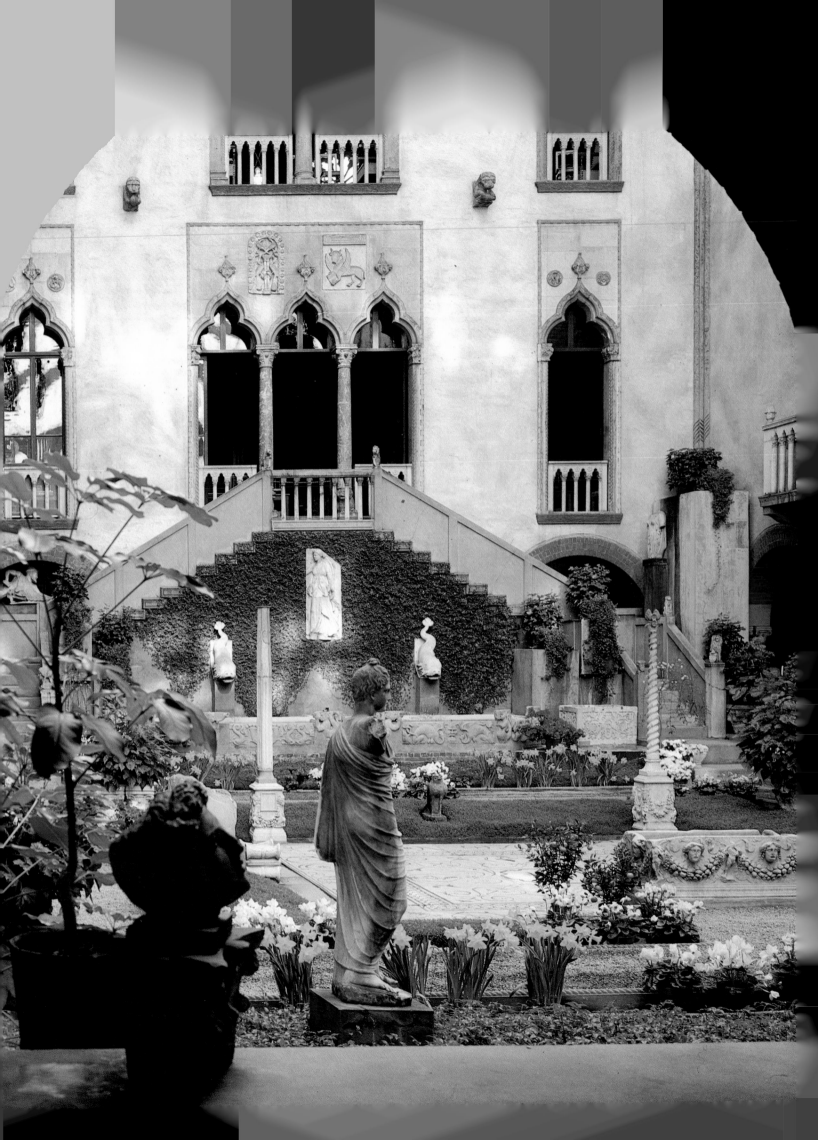

The Isabella Stewart Gardner Museum

Rollin van N. Hadley

Isabella Stewart Gardner's Museum may be the most personal museum in the world, because she herself fulfilled all the functions necessary to a museum. She selected the objects, paid for them, designed the building, superintended its construction, installed the collection, presided as Director and was the single benefactor. By the terms of her will, nothing may be added to the collection or loaned from it, and the general arrangement is to remain as she left it.

The museum is, therefore, a monument to her taste. Her purpose was to perpetuate not so much her name as her theories. She believed that works of art should be displayed in a setting that would fire the imagination: every step of the way should provide pleasure. Music and flowers were to Mrs. Gardner the logical accompaniment for the visual arts, and a place in the museum was provided for them. The tradition is carried on today although neither was mentioned in her will.

Every gallery has a character of its own and the works of art are arranged without regard for chronology or country of origin. Perhaps the best example of this is the Spanish Cloister, opposite the public entrance, designed as a setting for Sargent's *El Jaleo* (colour c). The gallery has rich blue tiles on the floor, a 'moorish' arch framing the picture, tiles from the floor of a Mexican church on the walls, a French Mediaeval doorway and an ornate Renaissance window. All of these elements combine to create a fictional ambiance for Sargent's flamenco dancer. It is a preamble to the real centre of the museum.

From the beginning the museum was planned with galleries opening on a flowering courtyard (colour A). The plan of the building, and indeed its character, is immediately established by this central core. Venetian windows and balconies are set into the interior façades that rise four floors to a glass roof, and the courtyard with the surrounding cloister holds most of the stone sculpture: architectural fragments, retables, statues and reliefs. Also on the ground floor are three small rooms which became the galleries for contemporary pictures during the twenty years Mrs. Gardner was rearranging the collection.

The illusion of being in a private house (an Italian *palazzo* in which a family has collected for generations) is enhanced by the unorthodox arrangement of the collection, and the variation in the rooms themselves. Early Italian paintings on gold ground are hung on white plaster while High Renaissance and Baroque paintings are on rich damask. The Tapestry Room (colour D) and the Gothic Room have rough wood panelling and heavy beamed ceilings. Pictures of importance, such as Raphael's *Portrait of Tommaso Inghirami* (No. 4) are placed near a window to receive favourable light. Most pictures are hung above a wainscot, slightly higher than a viewer's gaze. In the case of Piero della Francesca's fresco of *Hercules* (colour E), it is seen from below as it was when in the artist's house. One large canvas is set into the ceiling in the Venetian manner and is enhanced by a blue and

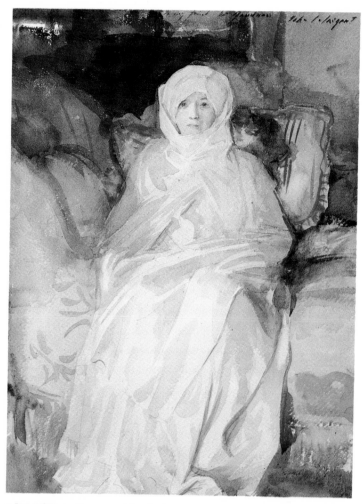

B. JOHN SINGER SARGENT. *Mrs. Gardner in White*, watercolour, 16¾ × 12½ inches.

gold coffered ceiling; its luxuriousness is picked up by the tooled, gilt leather on the walls. Cases contain special collections: prints and drawings (No. 3), lace, fine bindings, photographs, collected letters and manuscripts. All of the spaces have furniture and most have pieces of textile on tables, behind pictures, or displayed on the wall as a work of art.

As the main rooms and stair halls open on to the courtyard, no one who passes a window can avoid the pleasure of looking across into other galleries, watching the people on the balconies who are gazing at the flowers and the sculpture below. Because of the changing light from windows on two or three sides of each room, the aspect is always different; a particular painting may be favoured at one moment or a whole wall. At night under incandescent lamps on which no scholar would depend, there is a richness to the damask and the gold-leaf. With only slight imagination the cloister and courtyard take on centuries not apparent during the daylight hours. If a fire is lit, and chamber music is being played, there is no compulsion to examine anything closely, for the atmosphere of this singular creation casts a spell of its own. And so too, did Mrs. Gardner.

A. Courtyard, Isabella Stewart Gardner Museum.

Berenson once described Mrs. Gardner as Boston's pre-cinema star. Already a legend in her lifetime, to her biographers she remained complicated and elusive, unpredictable and fascinating. An outsider unintimidated by the cool reception awarded her at first by Boston society, she determined to set her own standards and do as she saw fit. '*C'est mon plaisir*' is the motto she placed outside her museum, and perhaps that best conveys the spirit of the founder.

Isabella Stewart was born in New York City in 1840, the daughter of a successful businessman. At a finishing school in Paris she met Julia Gardner, and then on a visit to Boston, Julia's brother Jack whom she married shortly before her twentieth birthday. Her first biographer, Morris Carter, wrote: 'The match was highly satisfactory to both families; Miss Stewart had wealth and charm; Mr. Gardner had wealth and position'. In Boston where ancestry was frequently cited, Isabella announced that as a descendant of Robert Bruce, she and Mary Queen of Scots were leaves on the same family tree. Neither tall nor beautiful, 'Mrs. Jack' had presence, and when she entered a room attention centred around her.

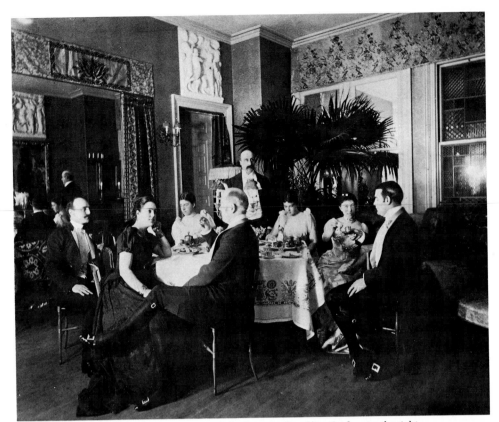

1. A party in the Beacon Street music room. Jack Gardner standing, Mrs. Gardner on the right.

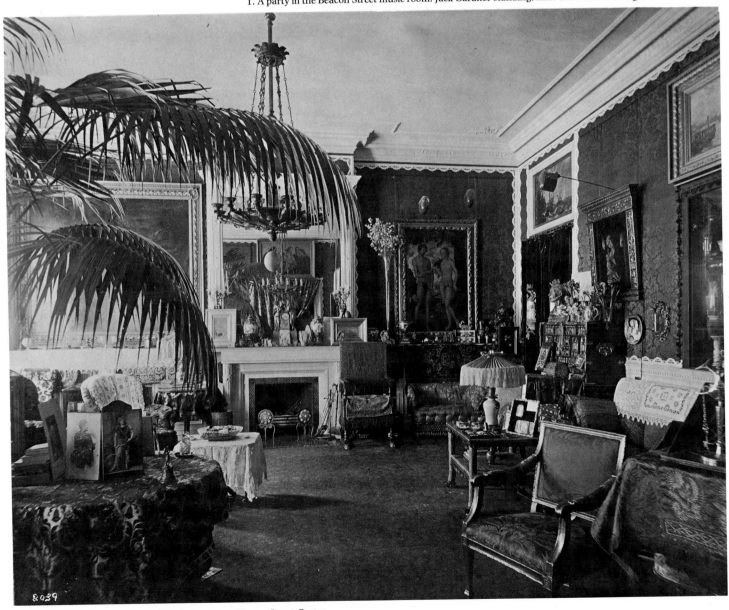

2. One of the rooms in the Gardner residence at 152 Beacon Street, Boston.

Perhaps life as a young society matron was not entirely fulfilling as may be inferred from the early accounts of frequent ill-health, culminating in depression when her baby died and she was forbidden by doctors from having another. She languished for two years until her doctors advised a trip abroad. She was carried to the ship as an invalid, but by the time it reached Europe her health had revived, and thereafter until late in life, hardly a day was spent in bed.

Eighteen months of travel in Europe increased her delight in museums and music and, particularly, in Paris and fashion. She returned home as the worldly Isabella, a transformation best summed up by Carter:

Quickly she became one of the most conspicuous members of Boston Society. Effervescent, exuberant, reckless, witty, she did whatever she pleased, and the men, the gayest and most brilliant of them, she captivated . . . It was Mrs. Gardner's rule to select and acquire the best. If she were attending a polo game, she would be escorted by the best player of the day; the best tenor of the opera, the best painter, the best art critic, the best judge of horses – these, each for a special purpose, were her friends

While Jack Gardner was alive, their house on Beacon Street saw much of fashionable Boston (No. 1). In 1880 the house next door was purchased in order to provide a suitable music room for concerts. Boston was dazzled by Mrs. Gardner's style: naturally her gowns came from Paris as did her carriages, drawn by swift horses and accompanied by two footmen in handsome livery. Her jewels, too, were legendary. When she met the King of Cambodia she wore two large white diamonds, and a yellow one which he much admired. To those and her exquisite pearls and rubies were added two more diamonds from Tiffany which she wore on gold wires from a diadem.

For the next thirty years travel abroad was indispensable to her. In 1874 she went up the Nile and through the Near East, writing her impressions in a diary or sketching what she saw. Later, in 1879, she and Jack took their three orphaned nephews, who had become their wards, on a tour of French and English cathedrals. On their way home from a trip around the world in 1883, the couple stayed five weeks in Venice where Jack's cousin, Daniel Curtis, owned the Palazzo Barbaro on the Grand Canal. Venice seemed civilisation and luxury to Isabella, weary from a year of travel in the Orient, the more so since young Ralph Curtis was their knowledgeable guide. Venice and its treasures left an indelible impression on her, and she began a collection of photographs of her favourite works of art. After this visit every trip to Europe included a stay in Venice, and every second year until 1899 found the Gardners at the Palazzo Barbaro, often for several months.

Mrs. Gardner's interest in Italian art had been nurtured by Charles Eliot Norton, Harvard's first Professor of Fine Arts. She had heard him lecture on Italy in 1878 and had joined the Dante Society which met at his house. Professor Norton enjoyed buying books and pictures, and with his encouragement she soon had a creditable shelf of rare books and manuscripts which was expanded during her lifetime, but never with the interest she was to bestow on works of art (No. 5).

In London in 1886 she was introduced to Sargent by Henry James – both of whom remained life-long friends – and acquired two pastels from Whistler; it was the start of her enthusiasm for buying pictures, and for the company of artists. As every European trip included music the Gardners went to Bayreuth to hear their friend Materna sing. Liszt died the night of their arrival, and Mrs. Gardner was invited to walk at the head of the funeral procession. On a later visit to Bayreuth, she met Brahms and Strauss, and on the back of a photograph of the two composers, Strauss penned the theme of the *Blue Danube*.

At home, the music room continued to be the setting for recitals and concerts. Paderewski played for her alone, again in a recital for her friends, and finally in a public performance to which Mrs. Gardner sent all the tickets to Boston's musicians. Amherst Webber, Charles Martin Loeffler and Ferruccio Busoni were among those to whom she gave friendship and assistance, and in turn they dedicated manuscripts to her. She helped Henry Higginson establish the Boston Symphony Orchestra and build Symphony Hall; together they laid the foundation for Boston's musical tradition.

Opera and the theatre also fascinated her. Lady Gregory, Sir Henry Irving, Ellen Terry and Anna Pavlova were among those entertained by Mrs. Gardner. But by far the largest group of friends were writers. Men of letters everywhere found her exhilarating, a generous patron and loyal friend. She constantly sought out young men of literary promise, and was a friend to George Santayana, F. Marion Crawford, T. S. Eliot, and Bernard Berenson when they were not yet known in Boston.

Mrs. Gardner was among those who provided a purse to enable Berenson to study abroad following his graduation from Harvard. He set out to be a literary critic but was soon engrossed in the study of art. In 1894, he sent his benefactor a copy of 'The Venetian Painters of the Renaissance' accompanied by the following letter:

. . . The little book that I now send is one for which I can count on more credit from you than from most people. You have travelled as few: and seen pictures with your own eyes; and I know you will understand the effort of one who has condensed into the smallest possible space a personally appreciative account of a fascinating school of painting. I promise myself the pleasure of sending you two or three other books in the course of the next two years; and if they succeed in reviving some of the interest you once took in me, I shall have my reward.

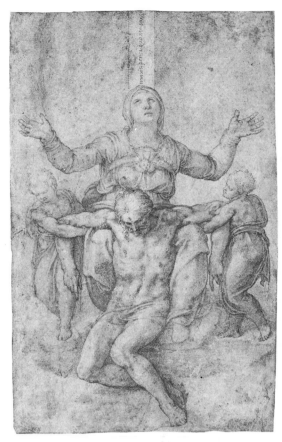

3. MICHELANGELO BUONARROTI.
Pietà (one of a group of drawings bought at the Robinson Sale, 1902),
black chalk on laid paper,
$11\frac{1}{16} \times 7\frac{1}{2}$ inches.

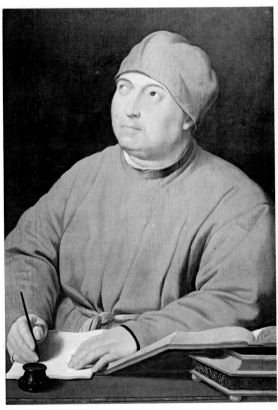

4. RAFFAELLO SANTI.
Count Tommaso Inghirami,
$35 \times 24\frac{1}{2}$ inches.

Mrs. Gardner's father had died in 1891, leaving an inheritance that enabled her to collect in earnest. Although she bought Classical, Mediaeval, Oriental, and purely decorative objects, her first love was European paintings. Relying on her own judgement, she purchased Vermeer's *Concert* and on the recommendation of Sargent, a magnificent seventeenth-century Persian carpet. When Berenson became her agent and principal advisor she bought very rapidly. He wrote to her that in his mind's eye 'your gallery possesses a masterpiece by each of the world's great masters'. Although the original plan may have been for a comprehensive collection, the Italian influence prevailed. Perhaps her am-

Right.
c. The Spanish Cloister,
the setting for Sargent's *El Jaleo.*

D. Fourteenth-century stone fireplace
in the Tapestry Room.

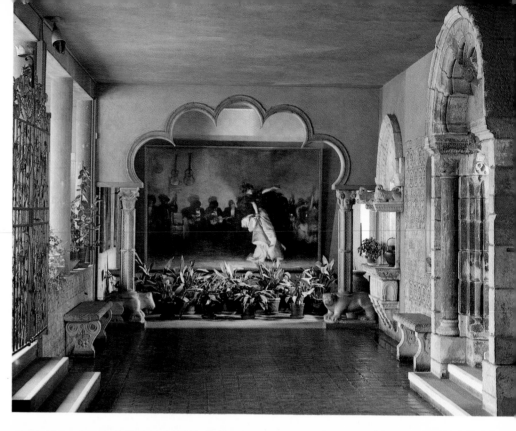

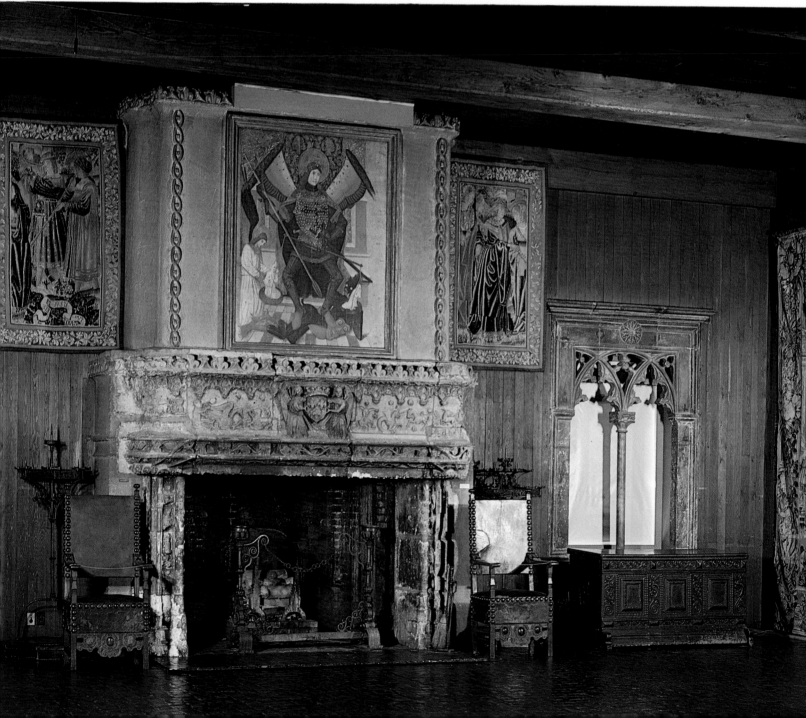

Right.
E. PIERO DELLA FRANCESCA.
Hercules, fresco,
59¼ × 49½ inches,
in the room of
early Italian paintings.

bitions were focused with the acquisition of Titian's *Rape of Europa* (colour A, page 40; No. 1, page 41), bought on a lucky chance after negotiations for Gainsborough's *Blue Boy* fell through. (Thereafter she avoided English portraits.)

As Mrs. Gardner's fortune was small in comparison with the famous American collectors of the next decades (Morgan, Frick, and Mellon), the faith she placed in Berenson proved to be the measure of success. Her allegiance to him never wavered even when her husband, her ultimate advisor, had his doubts. Witness this letter of January 1898:

Dear Berenson, I have so much to say I don't know where to begin. First + foremost, I, poor little me, am between the two horns of that dilemma! Mr. Gardner + you – Both most brutally unkind to me – ! He thinks I ought never to buy one other single thing I am so crippled; + you, you do scold me if I don't! He thinks every bad thing of you, + I too am beginning to look upon you as the serpent; I myself being the too-willing Eve

In the end, Berenson was responsible for the purchase of more than fifty pictures, several fine pieces of sculpture and, much later, choice Oriental objects which he then was buying for himself.

Since 1896 the Gardners had decided to have a museum of their own, and with that in mind they went abroad in 1897 to buy windows, balconies, doorways, columns, capitals, and decorative objects in marble, iron, and wood (colour D, No. 6). These were shipped to a rented warehouse in Boston. Jack Gardner's death at the end of 1898 did not prevent his widow from carrying out their intended plans for the museum. He had shared in the pleasures of collecting, and besides managing his wife's money and keeping the acquisition records, he had argued for placing the museum on the new parkland in the city's west end, where it was built after his death.

The Beacon Street houses had been filled to overflowing (not unlike museums of that period, No. 2). Paintings were stacked to the ceiling, hung over doorways or sometimes placed on an easel. Unusual fabrics covered the walls, often framed with a decorative wood border, or even thrown over tables and draped in doorways. Photographs and *objets d'art* littered the tables and sculpture filled in the corners or greeted the visitor in the stair halls. Fenway Court was an expansion of these ideas raised to a noble scale.

Instructing her architect not to proceed with any construction beyond pile driving, Mrs. Gardner returned to Europe, buying still more

F. Veronese Room.

for her collection and the building. In that year she bought a pair of portraits by Holbein, a Fra Angelico, a polyptych by Simone Martini and Botticelli's *Madonna of the Eucharist*.

The building now occupied all her energy. She arrived every day on the site with her own lunchbox, much to the consternation of the architect. Nothing was left to chance or to others; she selected each piece from the warehouse and watched while it was put in place. Plans were changed daily, and work completed was often thrown out along with the workmen. As the walls were made of massive masonry in the Italian manner, the building inspector objected that there were no steel beams, but as usual Mrs. Gardner had the last word. When the workmen, mostly Italians, could not understand her instructions, in English or Italian, she climbed a scaffold and with a sponge dipped in paint smeared the walls of the courtyard to produce the effect of marble.

One newspaper announced that she had bought an Italian palace and had had it shipped to Boston as a memorial to her late husband. Public interest in her mysterious construction did not abate, and curiosity was not satisfied by the fortress-like building which rose at the edge of town, revealing nothing of its interior.

By November 1901 Mrs. Gardner was able to move to her museum, Fenway Court, and on Christmas Eve the rector of the Church of the Advent consecrated the museum's chapel in a service before a small group of friends and family. (This chapel and the Gothic Room were not opened to the public during her lifetime.) During the following year as the collection was being installed, a few more friends were allowed to see it. Others had to wait patiently until one hundred and fifty invitations were issued for the night of 1 January 1903, for nine o'clock, punctually.

On that cold winter night, her guests crowded the entrance to the large Music Room where, on a balcony at the head of the double stairs, Mrs. Gardner received them. During a concert by the Boston Symphony Orchestra, she sat alone on the balcony in a gilt chair. When the music ended, the doors to the courtyard were opened. Japanese lanterns lit the gravel paths where guests wandered through palms and flowering plants toward the marble stair that led to the galleries. In Boston, perhaps in America, no one had seen anything like it. One person wrote: 'You are the Boston end of the Arabian Nights'.

The public was admitted in February and for a fortnight spring and fall thereafter. Tickets cost one dollar and only two hundred were sold each day. The collection had been incorporated in 1900, the date that appears on the front of

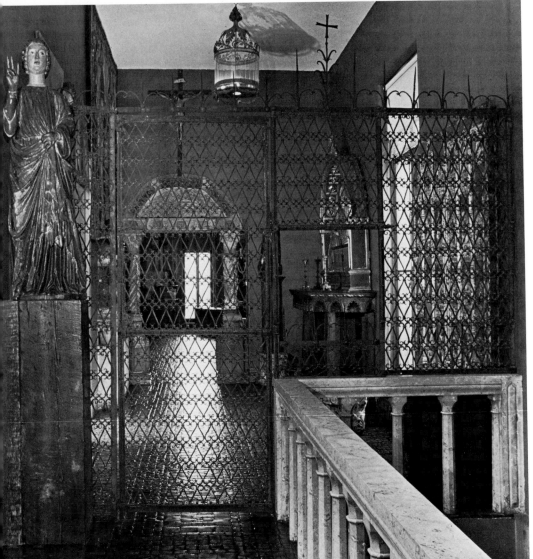

6. Third-floor stair hall.

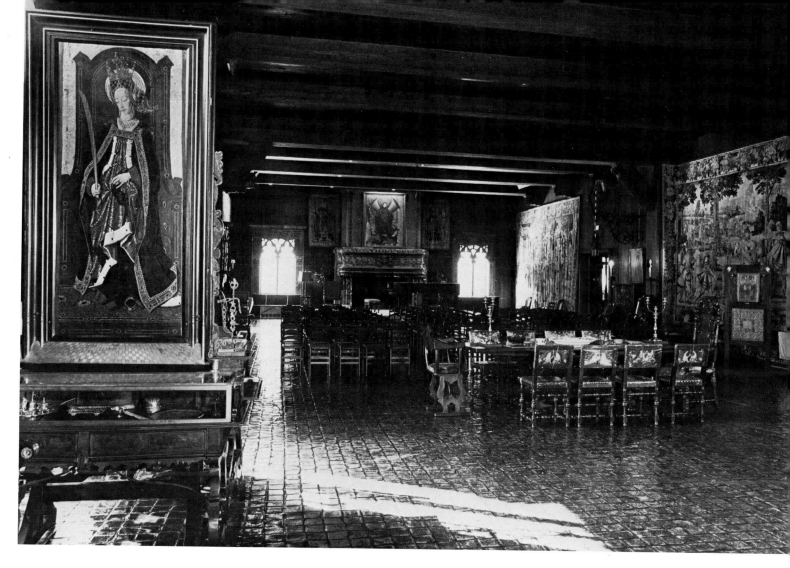

the museum. Mrs. Gardner greatly preferred the rest of the year when the museum was hers to show to interesting guests or for private entertainments, sometimes given to benefit a charity. On one memorable occasion in 1905, Melba sang. Following her performance, and an extemporary one from the top of the Court stairs, supper was served in the Dutch Room. In appreciation, Mrs. Gardner gave Melba the yellow diamond which had been coveted by the King of Cambodia.

As time went on Mrs. Gardner began to live more quietly. Conscious that she would have to endow the museum, she added to her collection only occasionally. New friends were made and she continued to support many charities, but her name was seldom in the newspapers' society columns.

In 1906 she went abroad for the last time and saw the Berensons in Florence and Henry James in London. She visited museums with a different eye. '. . . The Prado has such wonders', she wrote to a friend, 'They seem better and better, and worse and worse installed and cared for. My fingers itched to be made Director'.

Her remaining income was reduced by the crash of 1907 and by a large customs fine imposed on her the following year. (Just a year later the duty on antiquities was removed.) Nevertheless, in 1914 Mrs. Gardner decided to demolish the Music Room and replace it with the present Tapestry Room, where concerts are

now held, and galleries below, including the Spanish Cloister built for Sargent's *El Jaleo*. Depressed and saddened by the World War, she gave generously to the American Field Service. In her honour the founder named an ambulance the 'Y', which stood for Ysabella, a spelling used by Isabella of Spain, and sometimes by Mrs. Gardner. In 1919, she invited Morris Carter to become her Curator on the understanding that he would succeed her as Director. At the end of that year, Mrs. Gardner became partially paralysed and never walked again, though she maintained an active, busy schedule until her death in 1924.

In a letter to a friend she summed up her last years:

. . . I haven't a horse or anything now, but I am trying to keep up my courage. I'm quite an invalid but cheerful to the last degree. I think my mind is all right and I live on it. I keep up a lot of thinking, and am really very much alive. I live in one house, everything else having been sold. This house is very nice, very comfortable, and rather jolly. It is on the outskirts of Boston, not in the country. I have filled it with pictures and works of art, really good things I think, and if there are any clever people I see them. I really lead an interesting life. I have music, and both young and old friends. The appropriately old are too old – they seem to have given up the world. Not so I, and I even shove some of the younger ones rather close. I really have energy.

7. BARTOLOME BERMEJO (active 1468–1495). *S. Engracia*, in the Tapestry Room.

BIBLIOGRAPHY

There are two biographies of Mrs. Gardner: Morris Carter, 'Isabella Stewart Gardner and Fenway Court' (1925, reissued 1966 and available through the Gardner Museum), and Louise Hall Tharp, 'Mrs. Jack' (1965). There are chapters devoted to her in: Aline Saarinen, 'The Proud Possessors' (1958) and John Walker, 'Self-Portrait with Donors' (1974). Further information on her based on her correspondence is in the biography of Henry James by Leon Edel (1953–1972), and various articles in Fenway Court, the Museum's Annual Report. She also appears in a number of books about Boston at the turn of the century.

Rollin van N. Hadley is Director of the Isabella Stewart Gardner Museum.

Photographs.
Colour A and C: Joseph Pratt;
Colour B and D, Nos. 3 and 4: Herbert Vose;
Colour E: Richard Seron, Accent Productions;
Colour F: Lans Christensen;
Nos. 5–7: Larry Webster;
No. 2: T. E. Marr.

Mrs. Gardner's Modern Art

Deborah Gribbon

The collection of modern art at Fenway Court comprises paintings, watercolours, drawings, prints and sculpture produced, with few important exceptions, between 1850 and 1924. It is a large, disparate group which reflects neither a strongly defined nor particularly *avant-garde* sensibility. Following the dictates of friendship and whim, Mrs. Gardner assembled a personal collection of considerable interest.

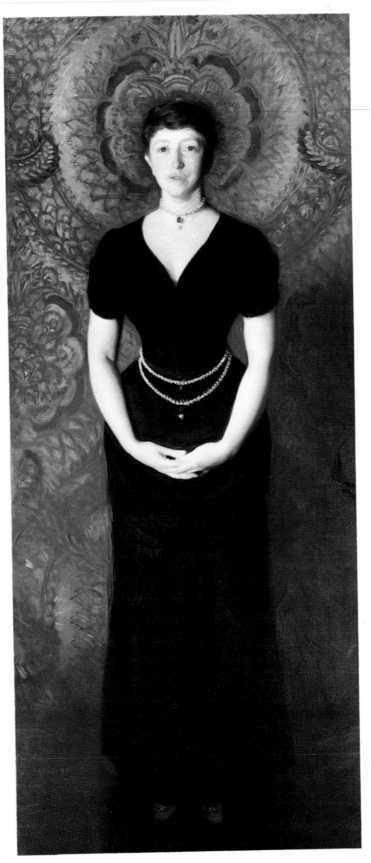

IN 1873, without thought of 'collecting', the Gardners' began to acquire a few small paintings to decorate their Beacon Street town house. Influenced by the prevailing taste, they bought the work of Barbizon masters. Their first purchase was Charles-Emile Jacque's *Sheep in the Shelter of Oaks* and by 1880 they owned respectable, if uninspired pictures by Diaz, Ziem, Troyon, Corot, and even a canvas by Gustave Courbet, *A View across the River* (No. 1).

During the 1880s Mrs. Gardner's activities as a patron of young musicians and writers brought her into contact with painters as well. The friendships initiated during this period inspired her to buy contemporary art. In the course of the next two decades, while concentrating her efforts on acquiring the work of Raphael, Titian, Rembrandt and Vermeer, Mrs. Gardner also pursued paintings by Sargent, Whistler, Zorn, LaFarge, and a number of local Boston artists.

The decision to become a patron of contemporary artists was prompted in part by Mrs. Gardner's friendship with Henry James. When she visited London in 1886 James took her to the Chelsea studio of John Singer Sargent to see a version of his *Portrait of Madame Gautreau* (No. 4). This painting had been the scandal of the Paris Salon of 1884; controversy centred on Madame Gautreau's revealing gown, but was certainly fuelled by her notoriety as a *femme fatale*. Delighted by the painting – and even more by the scandal it had provoked – Mrs. Gardner commissioned her own portrait, hoping perhaps to surpass the fame attached to Madame Gautreau. (Her interest in the latter was such that years later she acquired a small oil sketch, *Madame Gautreau drinking a Toast*, one of the first studies for Sargent's portrait.)

Sargent painted Mrs. Gardner (colour A) in 1887/8 during his second visit to Boston. Then aged forty-seven, she was not an easy subject and the artist made eight attempts before producing a portrait that pleased her. Both Sargent and Mrs. Gardner sought to emphasise the features for which she was famous: her graceful bearing, slender neck, and small waist. Sargent suggested the black shawl around her hips which limited the fullness of her skirt and created a more striking silhouette. Mrs. Gardner chose to set off her simple black dress with a pearl choker at her throat and two ropes of pearls around her waist, a large ruby suspended from each strand.

A. JOHN SINGER SARGENT. *Isabella Stewart Gardner*, 74¾ × 32½ inches.

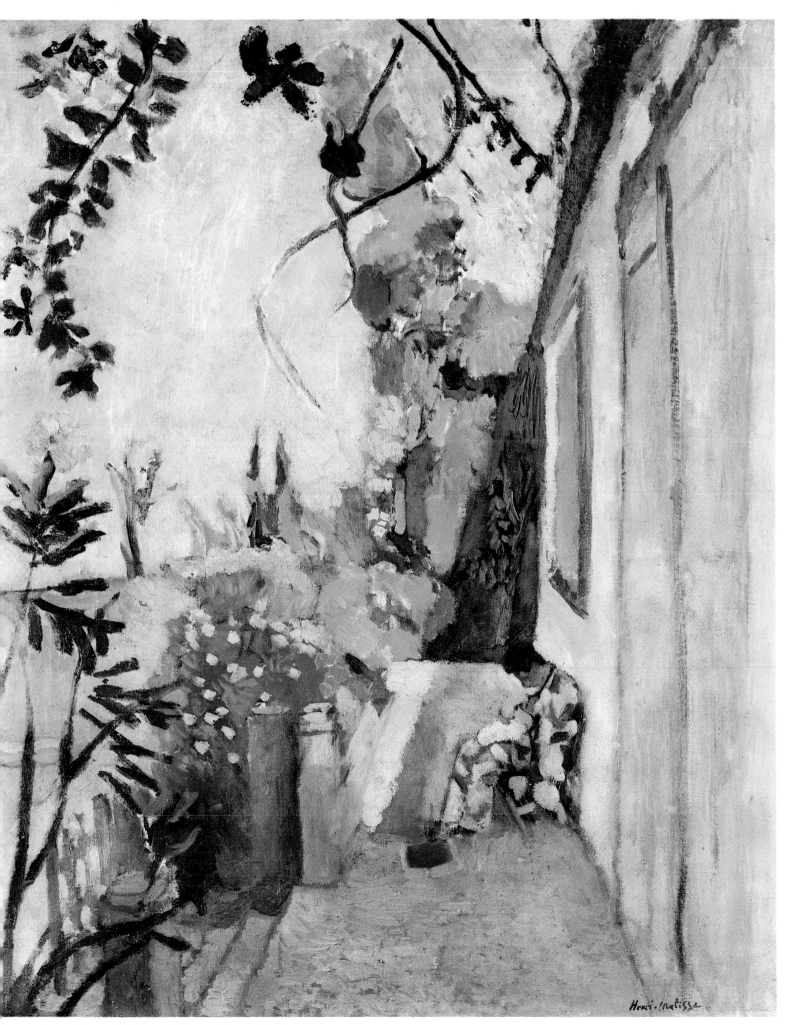

B. HENRI MATISSE. *The Terrace, St. Tropez*, $28\frac{1}{4} \times 22\frac{3}{4}$ inches.

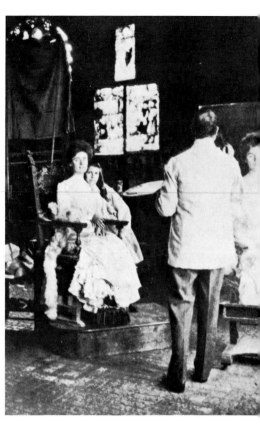

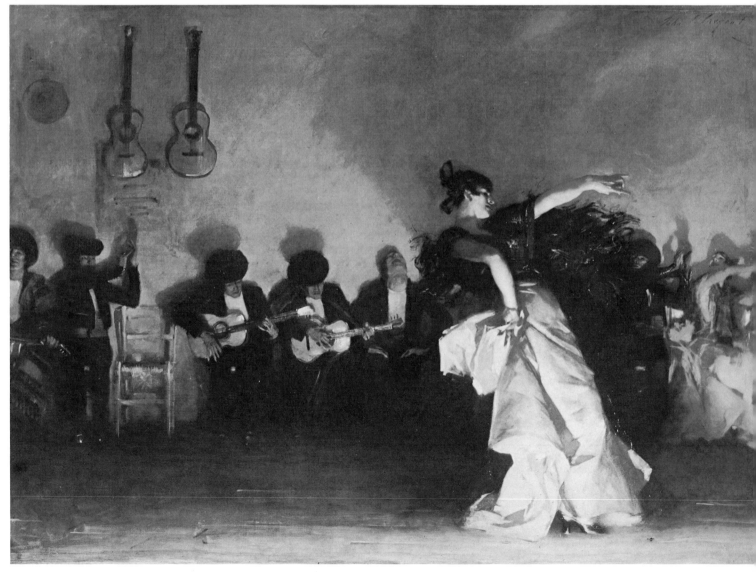

3. JOHN SINGER SARGENT. *El Jaleo*, 94½ × 137 inches.

Far left.
1. GUSTAVE COURBET.
A View across the River,
18 × 22 inches.

Left.
2. John Singer Sargent in the Gothic Room
with Mrs. Fiske Warren
and her daughter Rachel, 1903.

The portrait lacks the stylish verve that was the hallmark of Sargent's paintings: the formal, frontal pose and the abstract nature of repeated curves in both figure and background confer an iconic solemnity quite different from Madame Gautreau's languid sensuality. It did, however, receive its measure of notoriety. When exhibited at the St. Botolph Club in 1888 critics objected both to the *décollétage* (shocking perhaps by Boston standards but modest enough when compared to that of Madame Gautreau) and to the iconic quality of the image. One viewer was said to complain that Mrs. Gardner 'had herself painted as if she were a mediaeval saint'. At Mr. Gardner's request, the portrait was not exhibited again during his lifetime and the Gothic Room, in which it was placed at Fenway Court was closed to the public until Mrs. Gardner's death, although Sargent was once allowed to use it as a studio (No. 2).

As was so often the case with Mrs. Gardner, this commission provided the basis for an enduring friendship. Sargent's visits to Boston were infrequent but both were avid correspondents and through their letters they exchanged gossip and compared views on art. For the remainder of her life Mrs. Gardner continued to buy his work with the result that the museum now exhibits at least one painting from almost every decade of his career and each phase of his activity.

Among these the most famous is Sargent's *El Jaleo* (No. 3). Completed in 1882, its enormous success in the Paris Salon of that year established Sargent's reputation as one of the leading artists in Europe. The Salon visitors responded to the vivid portrayal of the Flamenco dance, but the painting itself is a curious blend of realism and theatricality. The setting is certainly that of the Andalusian dance halls that Sargent visited and sketched, yet the intense illumination could only be produced by the footlights of a Parisian stage. Each participant is closely observed in a moment of seemingly spontaneous action, yet the action is frozen and each gesture isolated. A folio of preparatory drawings that Sargent gave Mrs. Gardner reveals that although the artist made many sketches of dance performances, the pose, gesture and expression of each figure – even those in the background – were carefully sketched from models in the artist's studio.

Mrs. Gardner was particularly attuned to the dramatic impact of the *El Jaleo*. She first admired it in the collection of her cousin, T. Jefferson Coolidge who promised to bequeath it to her. The painting was publicly exhibited on several occasions; each time Mrs. Gardner objected that its effect was diminished by being lit from above. In 1914 the Music Room at Fenway Court was dismantled and Mrs.

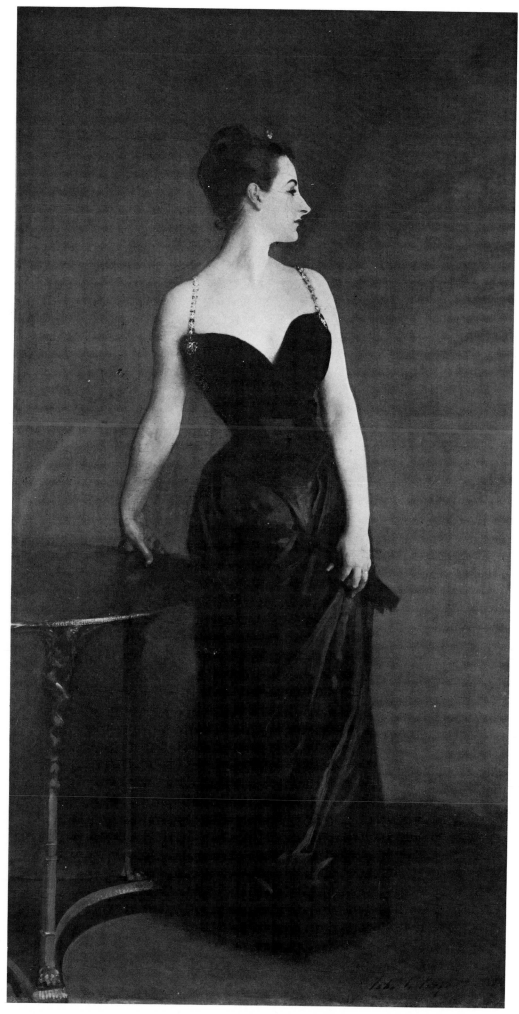

4. JOHN SINGER SARGENT. *Portrait of Madame X (Madame Gautreau). Metropolitan Museum of Art, New York.*

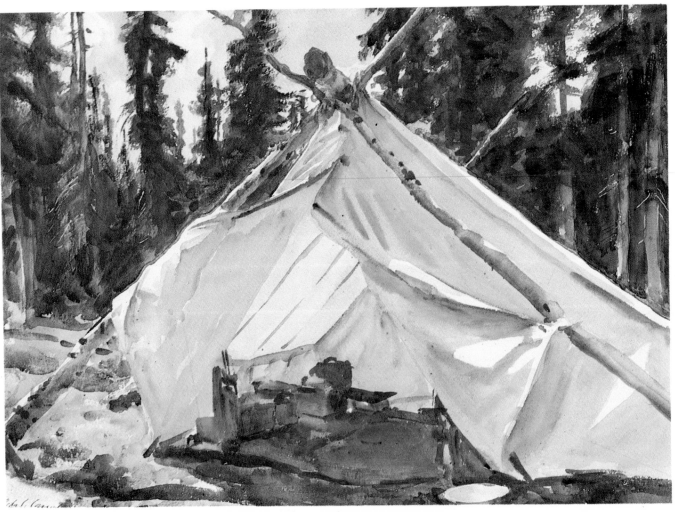

C. JOHN SINGER SARGENT. *A Tent in the Rockies*, watercolour, 15 × 20½ inches.

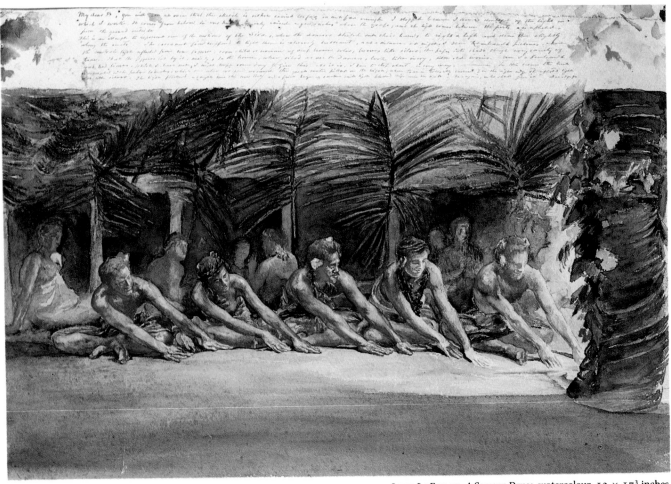

D. JOHN LAFARGE. *A Samoan Dance*, watercolour, 12 × 17¾ inches.

Gardner, determined to build a gallery in which the *El Jaleo* could be properly displayed, installed the Spanish Cloister on the first floor opposite the entrance (colour C, page 6). Mexican tiles covered the walls and at the far end a Moorish arch enclosed an alcove in which the painting would be placed: set into darkness and lit from below. When Mr. Coolidge saw this splendidly evocative setting he relinquished the *El Jaleo* immediately.

Mrs. Gardner acquired eleven of Sargent's watercolours – a testament to her persistence, for the artist rarely sold these more casual works. During the summer of 1916, when Sargent was supervising the installation of his mural decoration in the Boston Public Library, he took an extended vacation to camp in the Canadian Rocky Mountains. Mrs. Gardner commissioned one of the large canvases he painted while in the Rockies, but she was even more fortunate in obtaining a small watercolour of his campsite, *A Tent in the Rockies* (colour C). In this rapid sketch his white canvas tent, reflecting the cool mountain light, stands. in brilliant contrast to the rich colours of the surrounding forest.

Sargent's last portrait of Mrs. Gardner, presented as a gift from the artist, was painted at Fenway Court less than two years before her death. Once again Mrs. Gardner and Sargent contrived – though perhaps unconsciously – to present her at her best. She received Sargent dressed in a white robe, her head covered by a white veil so that only her face was visible. Exploiting the inherent transparency of water-

colour, Sargent transformed his aged and ailing friend into a brilliant, shimmering vision (colour B, page 3)

When Mrs. Gardner met Sargent in 1886 she already knew James McNeill Whistler and visited his studio regularly – another friendship inaugurated by a portrait, this one a small pastel. Mrs. Gardner called on the artist each time she travelled to London or Paris and never failed to leave without one or two purchases. By 1895 she owned a substantial number of Whistler's works.

Harmony in Blue and Silver: Trouville (colour F) is one of three paintings by Whistler in the collection. An early work, it was painted on the French coast in 1865 in the company of Gustave Courbet. Courbet is in the foreground, his back to the viewer as he looks out to sea. It is difficult to conceive of two artists more dissimilar in temperament. One need only compare *Harmony in Blue and Silver* to Courbet's *A View Across the River* (No. 1) to appreciate the distance between the two. Courbet's dense layer of paint approximates the tactile quality of the landscape he represents. Whistler's thinly brushed veils of colour, shore and ocean distinguished only by variation in tone, evoke the more ethereal aspects of nature: air, light and mist.

Mrs. Gardner also acquired Whistler's etchings and lithographs – at that time more popular than his paintings – and a number of small sketches the most charming of which are two pastels: *Lapis Lazuli* and the *Violet Note* (colour E).

E. JAMES ABBOTT MCNEILL WHISTLER.
Violet Note,
pastel on cardboard,
10¼ × 6¾ inches.

F. JAMES ABBOTT MCNEILL WHISTLER.
Harmony in Blue and Silver: Trouville,
19½ × 29¾ inches.

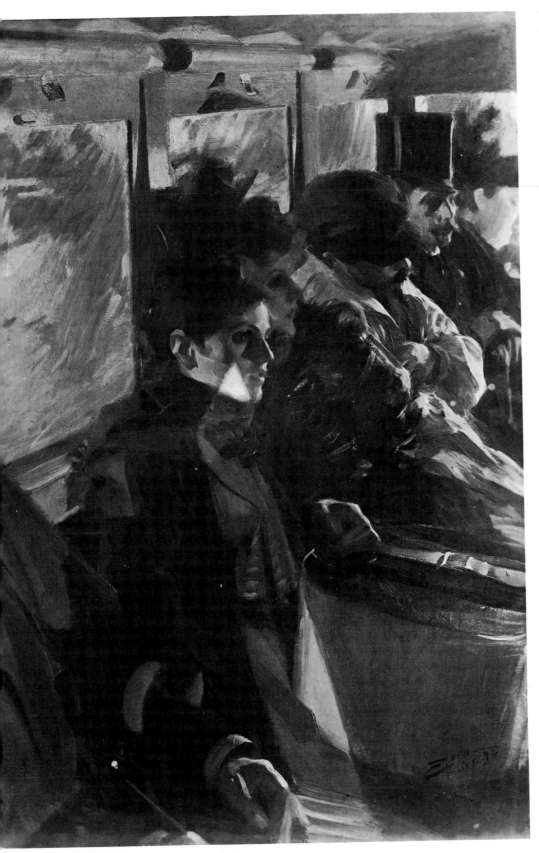

5. ANDERS LEONARD ZORN. *The Omnibus.* 49¾ × 34¾ inches.

the dark palette, limited to white, grey, black and ochre, and the attention given to pretty, anecdotal detail – the elegant features of the two women, the hat box that one holds in her lap – are more typical of artists like Jean Béraud who translated the *avant-garde* style into more acceptable form.

Zorn's talents were well suited to the medium of etching. He developed a suave, sketchlike style out of a surprisingly simple graphic vocabulary, using long, parallel strokes of heavily etched design in vivid contrast to the white of the paper. The museum has a particularly strong holding of Zorn's etched portraits. These include straight forward representations of society figures – some collectors in their own right, such as Mrs. Potter Palmer of Chicago – and more dramatic portrayals of artists and writers, including Paul Verlaine, August Strindberg and Ernest Renan (No. 6).

The growing contemporary collection also included the work of such prominent American artists as John LaFarge. Although Mrs. Gardner purchased LaFarge's painting *Old Barn Under Snow, Newport* at auction in 1878, it is not clear when she actually met the artist. Their correspondence dates from 1880, but they may have come into contact earlier, between 1872 and 1877, when LaFarge was in Boston completing his decoration of Trinity Church. A letter of 1884 suggests that Mrs. Gardner commissioned a stained glass window; the project was probably abandoned at an early stage for it received no further mention. Interestingly, LaFarge participated in the first attempt to catalogue Mrs. Gardner's collection. In 1907 he wrote the introduction to 'Noteworthy Paintings in American Collections', a book which contained essays on selected works from Fenway Court and four other private collections; intended as part of a series to be sold at the regal price of two hundred pounds per volume, only this first volume was published.

LaFarge shared Mrs. Gardner's love of travel and often captured his impressions in rapid sketches. One of the museum's three watercolours by LaFarge, *A Samoan Dance* (colour D), is just such a work, sketched during a voyage to the South Seas in 1890. It must have been sent as a letter to the artist's son Bancel for across the top it bears a long inscription that reads, in part:

My dear B. . . . This is an attempt to represent one of the motions of the Siva, when the dancers stretch out their hands to right & left and draw them lightly along the mats . . . Were I a Rembrandt and had I time, which I have not, I might hope some day to give this. As it is I have to stop short in every way.

During this early period of acquisition Mrs. Gardner's interest also extended to local artists, many of whom now occupy a prominent position in the collection. For example, in 1890 Mrs. Gardner began to purchase watercolours by Dodge Macknight; by 1915 she had acquired fourteen and hung them together in a room at Fenway Court named for the artist. Others who enjoyed her friendship and con-

In 1893 Mrs. Gardner 'discovered' the Swedish artist Anders Zorn. She saw Zorn's *The Omnibus* at the World's Columbian Exhibition held in Chicago, sought out the artist and bought the painting on the spot. A friendship evolved, which led to the purchase of paintings, drawings and etchings, among them, portraits of Mrs. Gardner in all three media.

The Omnibus (No. 5) depicts six passengers sitting in the cramped space of a Parisian bus. Zorn's bold close-up view, unusual angle, arbitrary cropping (the head of the passenger who sits closest to the viewer is not visible) and concentration on the effect of light as it pours through the bus windows are evidence of his interest in the work of Manet and Degas. But

sequent patronage include Dennis Bunker, Martin Mower, Howard Cushing, Louis Kronberg and George Hallowell.

Fewer in number, but perhaps more interesting, are the examples of sculpture that Mrs. Gardner acquired. She owned two portrait-medallions by Augustus Saint-Gaudens; one, a portrait of Sargent, was given to her by the sculptor, perhaps in reparation after he refused her commission for a medallion of Paderewski. Later, Mrs. Gardner added the work of Anna Coleman Ladd and Paul Manship to her collection.

The artists that she befriended often advised and assisted Mrs. Gardner in further acquisitions. Sargent recommended the purchase of paintings by Helleu and Mancini; a portrait by Thomas Wilmer Dewing was bought on the advice of Dennis Bunker. Dodge Macknight assembled the Mexican tiles that adorn the walls of the Spanish Cloister.

After the opening of Fenway Court in 1903, Mrs. Gardner, finding the cost of Old Masters increasingly beyond her, began to acquire modern art with even greater vigour. On the recommendation of Bernard Berenson she expanded her interests and purchased two of the most important paintings in the modern collection, Edouard Manet's *Portrait of Madame Auguste Manet* (No. 7) and Edgar Degas' *Portrait of Madame Gaujelin* (colour G).

Manet's striking portrayal of his mother is the more imposing. A widow, Madame Manet is dressed entirely in black and sits placidly, stolidly with her hands resting on her lap. She fills almost the entire canvas, her full skirt spreading to either side. A date between 1862 and 1869/70 has been suggested for the portrait. The earlier attribution, perhaps 1862/3, is more appropriate. At this moment Manet, still a relatively young man, was painting the *Déjeuner sur l'herbe* and the *Olympia* (both in the Jeu de Paume, Paris). Both canvases provoked the public by their blatant presentation of sexual subject matter and their uncompromisingly new technique. Although of a different *genre*, the *Portrait of Madame Auguste Manet* is typical of this new style in its simplified modelling of facial planes, dark palette, and stark contrasts between the dark background, dress, hair and veil, and the bright islands of face and hands. The canvas is broadly brushed – a painterly equivalent for the boldness with which Madame Manet, indeed the painting itself, confronts the viewer and commands his attention. Yet within this forceful presentation Manet employed the subtle touches that characterise his still-lives of the same period: fine differentiations of black are coaxed from the dress and the darkness of the painting as a whole is gracefully relieved by a narrow edge of salmon upholstery on the back of the chair.

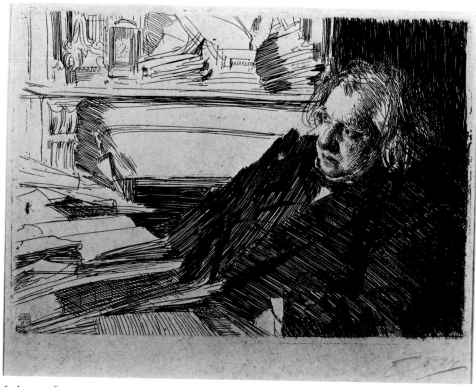

6. ANDERS LEONARD ZORN. *Ernest Renan*, etching, 9¼ × 13¼ inches.

7. EDOUARD MANET.
Madame Auguste Manet,
38½ × 31½ inches.

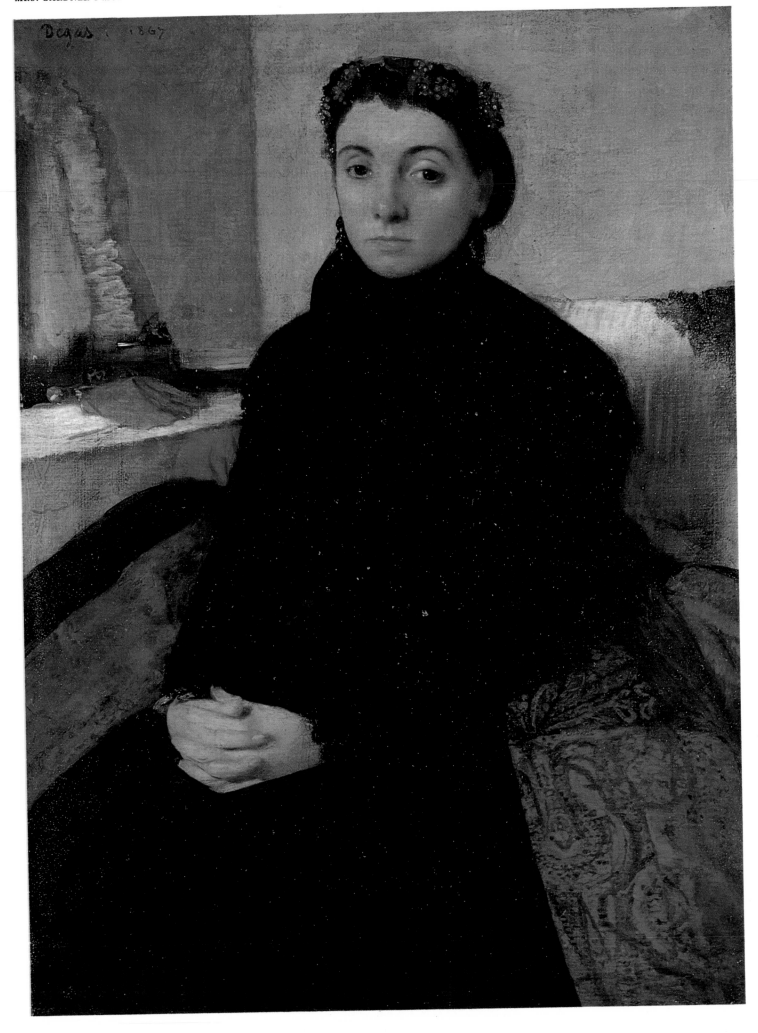

Degas' portrait of *Madame Gaujelin* (colour G), dated '*1867*', is smaller and more muted. The subject, Joséphine Gaujelin, was a Parisian dancer and, later, an actress. She, like Madame Manet, is dressed in black. But Manet focused attention only on the figure, suppressing details of costume and obscuring the background; Degas used exactly these elements to elaborate his portrait. The paisley cushions among which Madame Gaujelin sits, the bureau, the warm yellow walls provide a context for the figure. Degas' eye for the eloquent detail picks out small touches of dress that evoke character. The thin shawl delicately studded with seed pearls, the hat decorated with tiny clusters of grapes and the laced cuffs of the dress suggest the highly refined sensibility of the sitter. Many of Degas' female subjects share this high strung, slightly apprehensive quality. It is, for example, even more pronounced in the expression and bearing of Thérèse Morbilli in the double portrait of the *Duke and Duchess of Morbilli* (No. 8) in the Museum of Fine Arts, Boston. Perhaps Degas saw this quality as characteristic of the feminine psyche or even projected aspects of his own personality onto his subjects. Comparison with another study Degas made of Madame Gaujelin (Kunsthalle, Hamburg) indicates that she was considerably younger and less dour than she appears here. Perhaps for this reason she rejected the portrait she had commissioned.

The most modern and, perhaps, the most surprising artist to discover at Fenway Court is Henri Matisse. His work was brought to Fenway Court by an archaeologist, Thomas Whittemore, an American active in Egypt and responsible for uncovering the mosaics at Hagia Sophia in Constantinople, who was a close friend of both Matisse and Mrs. Gardner. Whittemore was so anxious that the museum have examples of the artist's work that he gave Mrs. Gardner a painting and four drawings. *The Terrace, St. Tropez* (colour B), presented to Mrs. Gardner in 1912, was the first Matisse to enter an American museum. The terrace, according to Whittemore, is that of the Neo-Impressionist Paul Signac; the seated woman, clad in a kimono, is Madame Matisse. Matisse spent the summer of 1904 in St. Tropez working with Signac and his colleague Henri-Edmond Cross. Matisse had already been affected by their brilliant palette when he painted *The Terrace*, but had not yet succumbed to the *pointillist* technique. The painting's tonal structure is particularly intriguing; the wedge of deep shadow to Madame Matisse's left prefigures the compositions Matisse developed many years later to order his flat areas of colour.

It is fitting tribute to Mrs. Gardner's taste and ageless vitality that within the confines of her collection should reside one of the most modern artists of the following generation.

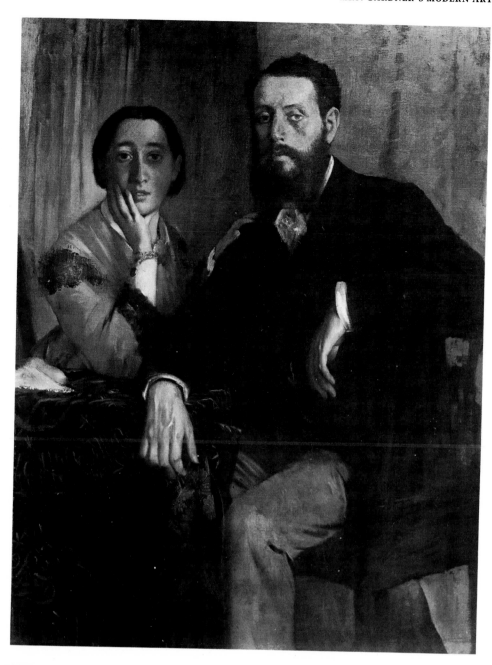

8. EDGAR DEGAS.
Duke and Duchess of Morbilli.
Museum of Fine Arts, Boston.

Bibliography.
The paintings discussed in this article are catalogued in P. Hendy, 'European and American Paintings in the Isabella Stewart Gardner Museum', (Boston, 1974). More detailed discussions of many of the objects may be found in the following articles in 'Fenway Court': D. B. Burke, '*Astarte*: Sargent's Study for the *Pagan Gods Mural* in the Boston Public Library', 1976; S. W. Day, 'Two Medallions by Saint-Gaudens', 1968; R. T. Dickinson, 'Degas' *Madame Gaujelin*', 1967; W. Hancock, 'Paul Manship', 1966; L. V. Hewitt, '*Love's Greeting* (Dante Gabriel Rossetti)', 1969; R. W. Karo, 'Ah Wilderness! Sargent in the Rockies, 1916', 1976; D. McKibbin, 'Sargent's Watercolors of Venice at Fenway Court', 1970; and R. Ormond, 'Sargent's *El Jaleo*', 1970.

Deborah Gribbon is Curator
of the Isabella Stewart Gardner Museum.

G. EDGAR DEGAS.
Madame Gaujelin,
$23\frac{1}{2} \times 17\frac{1}{2}$ inches.

Photographs.
Nos. 1, 3, 5 and 6: Joseph Pratt;
Colour A–D, F, G and No. 7: Herbert Vose;
Colour E: Barney Burstein.

Mediaeval Sculpture

Walter Cahn

1. *Entry of Christ into Jerusalem,*
Parthenay, Notre-Dame-de-la-Couldre, middle of the twelfth century, limestone,
48 × 53 × 8 inches.

Mediaeval sculpture was not so close to Mrs. Gardner's heart as her beloved Old Master paintings or the art of John Singer Sargent. But she acquired a sizeable collection for her palatial museum on the Fenway. It is an *ensemble* of varied interest and quality, not as well known as it deserves to be.

Mrs. Gardner's love for Venice and her decision to give Fenway Court the appearance of a princely residence on the Rialto accounts for its Italian characteristics, re-created in Boston with the help of quantities of decorative medallions (*patere*), fragmentary reliefs and architectural sculpture of all kinds, which the Gardners purchased in the course of several journeys to Venice and Rome between 1892 and 1897. In a modest way, the Gardner's *fin de siècle* sensibility had a pioneering side. As far as I know, this group of early Mediaeval and Romanesque sculpture was the first to have been brought to this country.

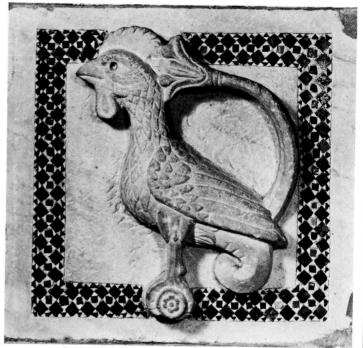

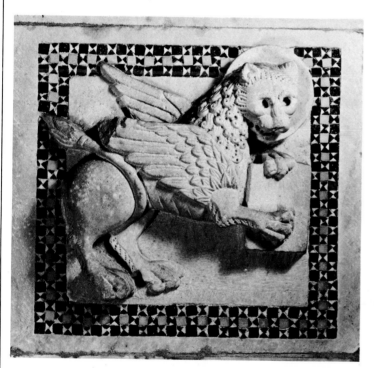

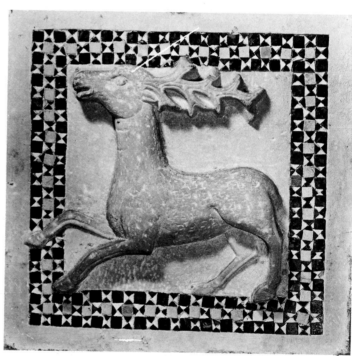

2. Architectural and sculptural elements from an ambo in the church of Santa Lucia, Gaeta, South Italian, first quarter of the thirteenth century, marble with green and red porphyry.

AMONG the Romanesque pieces, the pair of kings and the mounted figure of Christ from an *Entry of Christ into Jerusalem*, acquired in 1916, once enjoyed something close to handbook renown (No. 1). Together with a number of additional reliefs, now divided between several collections, they were seen in the nineteenth century in a garden adjoining the church of Notre-Dame-de-la-Couldre at Parthenay (Deux-Sèvres). It must be presumed that they were once part of the façade decoration of that monument, of which only the lower storey still stands. Such carvings of large dimensions and high relief placed in arched recesses are a distinctive feature of twelfth-century church façades in Poitou and

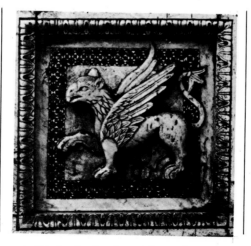

3. Architectural and sculptural element from an ambo in the Church of Santa Lucia, Gaeta, South Italian, first quarter of the thirteenth century.

Saintonge, and that at Parthenay still exhibits the poorly preserved remains of a Samson in combat with a lion and an even more fragmentary equestrian figure, perhaps Constantine. The figure of Christ, seated on a donkey, raises his hand in blessing. In the traditional *adventus* composition, the welcoming crowd at the gates of Jerusalem would have completed the scene, and the familiar motif of the cutting of palm branches thrown in homage at the feet of Christ may be inferred from the remains of a tree along the right edge of our relief. The work was unfortunately depreciated by a restoration before its acquisition which sharpened its worn contours but sacrificed much of the original surface in the process.

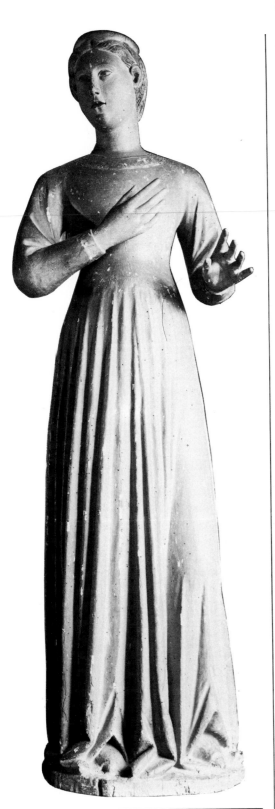

4. *Annunciate Virgin*,
Sienese, late fourteenth century.
Musée Jacquemart-André, Paris.

A *Christ* in polychromed wood (colour A) was the central figure of a Deposition group, which must have included representations of other participants in the sacred drama: Joseph of Arimathea and Nicodemus lowering the body from the Cross, and several mourners on each side. The body is slim and somewhat angular, and the quietly expressive head seems once to have borne a crown. Statuary groups of this kind were a new development in the Romanesque period. Their function has not yet been satisfactorily explained, though it is possible, that they were employed in a dramatic re-enactment of the Entombment in the Good Friday liturgy. Those that have survived belong to two distinct groups, one found in Central Italy, the other in Catalonia. Although no specific information about the provenance of the Gardner *Christ* has as yet come to light, its style makes probable a Spanish origin.

In contrast to this work, the white marble and mosaic encrustation fragments casually embedded in the wall of the museum's East Cloister are apt to be overlooked. The principal elements are four square panels framed by mosaic borders (No. 2). Two of them show haloed and winged animals displaying open books, a lion and an ox, the symbols of the evangelists Mark and Luke. A stag and a rooster with the curling tail of a dragon – the basilisk of Mediaeval bestiaries – are seen on the others. The symbols of Matthew and John and panels showing a siren and a griffon are part of additional pieces of the same monument which can be seen in the church of Santa Lucia in Gaeta (No. 3). The work was evidently dismantled when the interior of this Mediaeval structure was remodelled in Baroque times. It must have been a chancel barrier, perhaps equipped with a pulpit similar to those in a number of churches in Rome and the Campagna, which exhibit the same mosaic inlay technique. This was the trademark of certain Roman craftsmen of the twelfth and thirteenth centuries, comprehensively designated the 'Cosmati', and the panelled composition of the Gaeta ambo appears also in the chancel barriers of San Cesareo in Rome and Santa Maria at Civita Castellana, two of their more significant constructions of this type. A thorough study of the Gaeta and Gardner fragments, aided by archaeological exploration, might permit an accurate reconstruction of the original appearance of the monument.

The statue of an angel in polychromed wood is part of an *Annunciation* group, whose missing half, following a suggestion initially made by the Italian scholar Enzo Carli, is now generally acknowledged to be a figure of the Virgin in the Musée Jacquemart-André, Paris (Nos. 4 and 5). The archangel, with his right arm half upraised in a gesture of greeting, is clothed in heavy robes drawn in cascading folds across the body. This noble, classicising dress conveys an impression of movement and is in studied contrast to the simple, clinging robe of the Virgin. The existence of a number of such *Annunciation* groups in Gothic sculpture of Tuscany is likely to reflect some special pattern of devotion, and

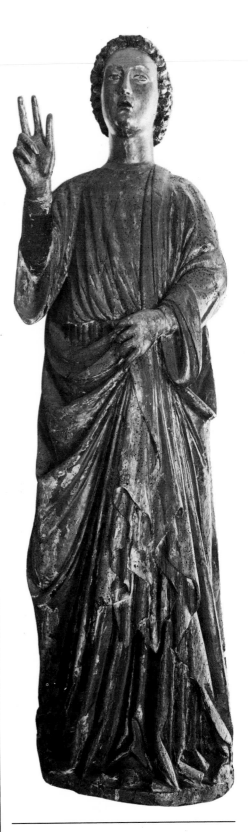

5. *Angel of the Annunciation*,
Sienese, late fourteenth century,
polychromed and gilt poplar.
Height: 66 inches.

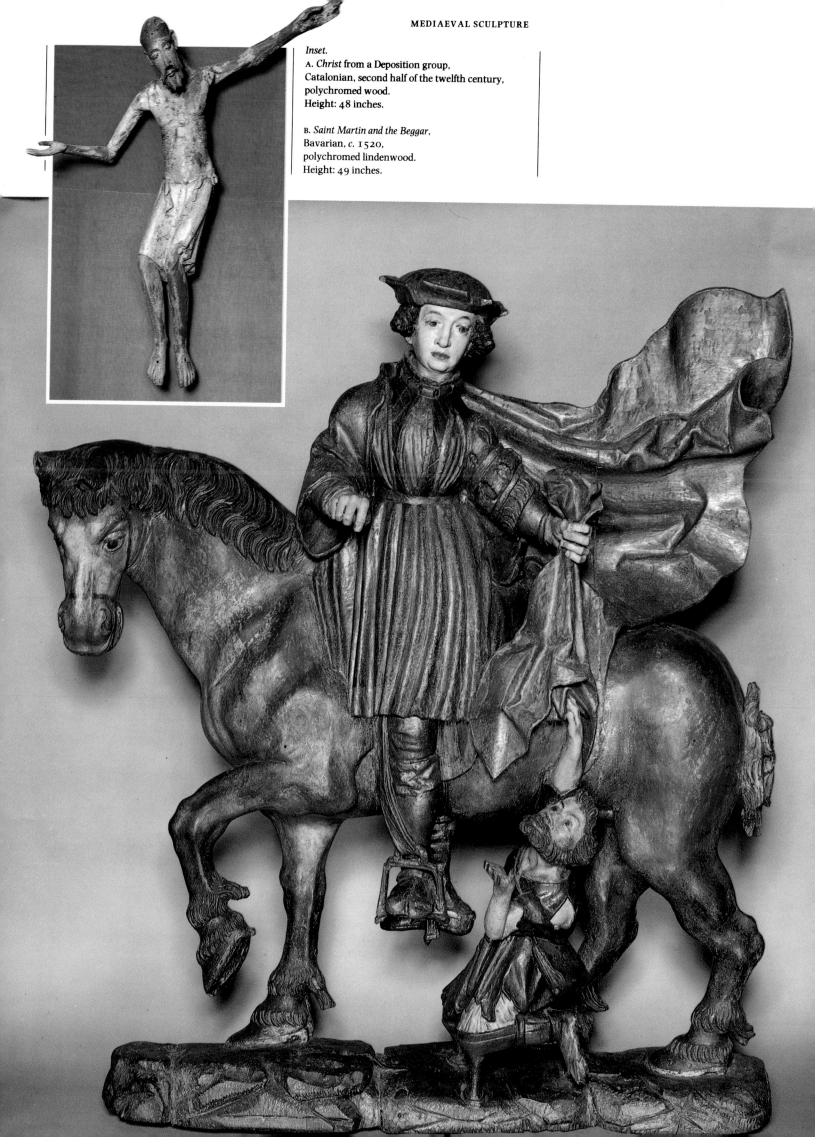

Inset.

A. *Christ* from a Deposition group,
Catalonian, second half of the twelfth century,
polychromed wood.
Height: 48 inches.

B. *Saint Martin and the Beggar,*
Bavarian, *c.* 1520,
polychromed lindenwood.
Height: 49 inches.

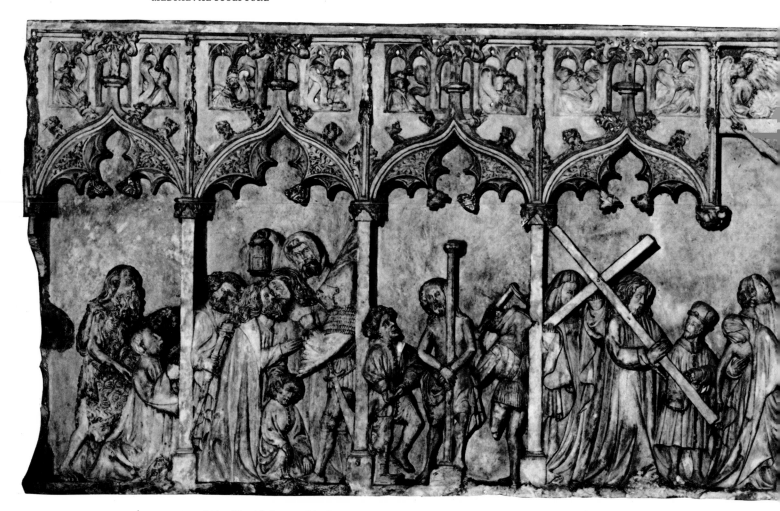

6. Retable with Scenes of the Passion, Lorraine, *c.* 1425, limestone, 31 × 108 inches.

it might be noted that a new religious Order, the Servites (Servants of Mary), founded in 1240 and strongly implanted in Tuscany, dedicated its churches to the *Annunziata.* The Gardner-Jacquemart-André group is of Sienese workmanship. Various dates, from 1383/5 to after 1410 have been assigned to it, but Brandi's attribution to the sculptor Domenico di Niccolò, called 'dei Cori' for his authorship of the *intarsie* in the choir of the Palazzo Pubblico, has gained general acceptance. Too little, however, is known about the style of this sculptor to be certain.

A limestone retable from eastern France is an attractive work, enhanced by recent cleaning and the removal of unsightly repairs (No. 6). The oblong slab, made up of two pieces of stone, is subdivided by an arcade into nine compartments housing scenes of the Passion. The Crucifixion appears at the centre. On the left are seen the Arrest of Christ, the Flagellation and the Carrying of the Cross. On the right of the Cross appears a group of astonished bystanders, with the Descent from the Cross and the Three Marys at the Tomb under the following two arches. Two kneeling donors presented by their patron saints, John the Baptist and Catherine, occupy the spaces at the extremities. Above the ornate ogee arches topped by leafy pinnacles, there are windows in *trompe l'oeil* with prophets wielding scrolls. The retable is nearly identical in certain parts to an altar still in place in the chapel of St. Barbara

within the church of St. Etienne at Vignory (Haute-Marne) on the eastern confines of Champagne (No. 7). The donors of both works are the same. They are identified by coats-of-arms placed near the male figure as Guillaume Bouvenot and his spouse Gudelette, of whom little else, unfortunately, is known. Their epitaph in the same chapel yields the date 1424. The chapel itself had been founded during the fourteenth century by a bailiff of Saint-Dizier and Vignory, and this suggests that Bouvenot was employed in a similar capacity by the castellan of Vignory, seneschal and governor of Burgundy. The Bouvenots must have ordered two retables from the same workshop in connection with separate foundations, the second probably in another church of the region.

This body of sculpture points to the existence of a workshop whose considerable activity spanned the first four decades of the fifteenth century. Its clients comprised a number of the leading noble families with connections to the court of the dukes of Lorraine established at Joinville, to the north of Vignory. This sculpture bears the strong imprint of the Gothic International style. The crowded panorama of finely garbed figures in picturesque animation which fills the Gardner retable confirms this affiliation. Sluter's more robust art in nearby Burgundy seems by contrast to have made no impression on our sculptor.

The newer and more monumental canons of form to which the International Style even-

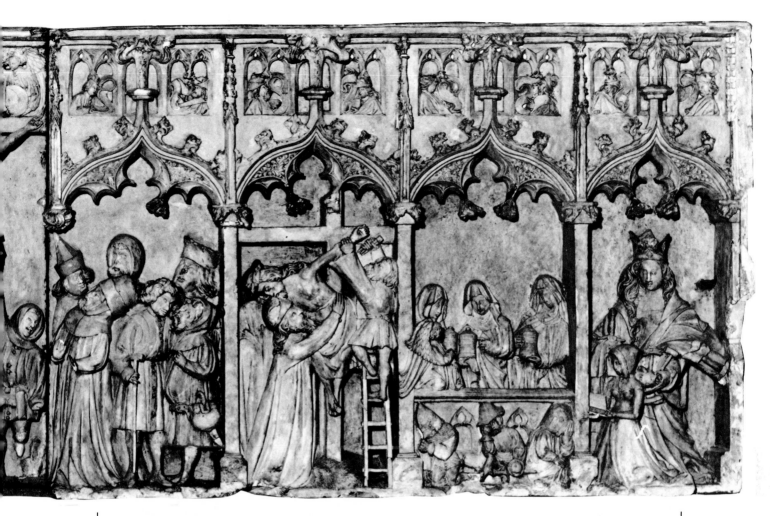

7. Retable with Scenes of the Passion, Lorraine, *c.* 1425, church of St. Etienne at Vignory.
Kunsthistorisches Institut der Universitat des Saarlandes.

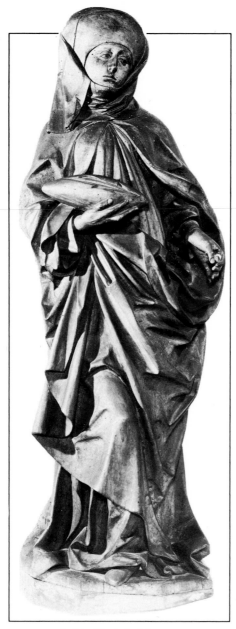

8. *Saint Elizabeth of Hungary*,
Upper Rhenish or Swabian, *c.* 1490,
lindenwood. Height: 47 inches.

tually succumbed are well represented in the
linden wood statue of Saint Elizabeth of
Hungary, probably carved on the Upper Rhine
or in Swabia *c.* 1490 (No. 8). Renowned for her
works on behalf of the poor and the sick,
Elizabeth died in 1231 and was canonised four
years later. This figure is one of numerous
reflections of an active cult, centred around the
saint's magnificent shrine at Marburg. The
figure is clothed in voluminous robes, and a
nun's wimple envelops the head, dramatically
isolating the face. The saint carries a loaf of
bread and probably held a jug in the other hand
– traditional attributes of her charity, but
perhaps also chosen for their Eucharistic
connotations.

The altar shrine of the Trinity with Saint
Catherine and a bishop saint is a north German
work, made of oak, as is generally the case for
wood sculpture of this region (No. 9). Wearing
an elaborate crown, God the Father at the
centre presents the suffering Christ, who dis-
plays His wounds. Catherine stands at the left,
gazing at an open book and holding the spoke

of a wheel, the instrument of her martyrdom.
At her feet is a diminutive figure of her tor-
mentor Maxentius, represented in half-length.
The unidentified bishop at the right, perhaps
Saint Nicholas, as has been thought, holds a
crozier and gestures in blessing with the other
hand. Above these figures is an intricately
carved arched gable filled with an openwork
tracery of foliage. The wings of the shrine
which were either painted or filled with
additional carved figures, are lost, and the
present wooded enclosure is modern. Walter
Paatz has recognised in the work the hand of
the Imperialissima Master, so named after an
altarpiece in the church of St. Martin at Hald in
Denmark, which bears an inscription contain-
ing the unusual formula '*Imperialissima Virgo
Maria*'. The Master must have been an assist-
ant or close collaborator of the Lübeck painter
and sculptor Bernt Notke (died 1509), for his
art depends in its essence on the latter's formal
and typological inventions. Like Notke himself,
the Imperialissima Master found an eager
clientele in Denmark, southern Sweden and
the German merchant communities along the
upper Baltic coast. According to Paatz, he was
perhaps Henryk Wylsynck, who is mentioned
in the documents as having had a hand in the
elaboration of Notke's great Saint George
monument in the church of St. Nicholas in
Stockholm (1483–1489), and later as an
executor of the Lübeck Master's testament. The
Gardner shrine is likely a work of the second
decade of the sixteenth century. Its Trinity is
very similar to the artist's *Gnadenstuhl* from the
altar of Tjustrup in the Copenhagen National
Museum, which, though probably earlier in
date, shows the same taut-skinned figures,
disproportionately elongated in the upper half
of the body in an effort to adjust their scale to
that of standing personages on either side.

The Gardner Museum possesses other ex-
amples of German wood sculpture of the same
period, most of them, unfortunately, less easy
to localise with the same degree of precision. A
number of south German and Austrian carv-
ings in the collection illustrate different aspects
of the impact of the Renaissance on a still very
vital late Gothic tradition. The brightly painted
linden wood relief of *Saint Martin and the Beggar*
(colour B) is a Bavarian work datable *c.* 1520.
The representation of the saint on horseback
dividing his cloak takes the nearly iconic form
inaugurated in thirteenth-century German
sculpture with the striking relief at Bassenheim
and tirelessly repeated thereafter. Martin
wears an elegant doublet with a slashed collar
and sleeves, short breeches and a fetching cap.
The crippled beggar in tattered garments – his
deformity is an unusual touch – reaches up to
grasp the billowing cloth of the saint's cape. His
small size in relation to his benefactor as well as
his profile stance lead the eye more emphati-
cally to the rider, whose charitable act is made
into an oddly solemn transaction. The well-
muscled horse, too, has an imposing presence,
in which something of the heroic air of the
animals of *Quattrocento* equestrian monu-
ments in Italy is in evidence.

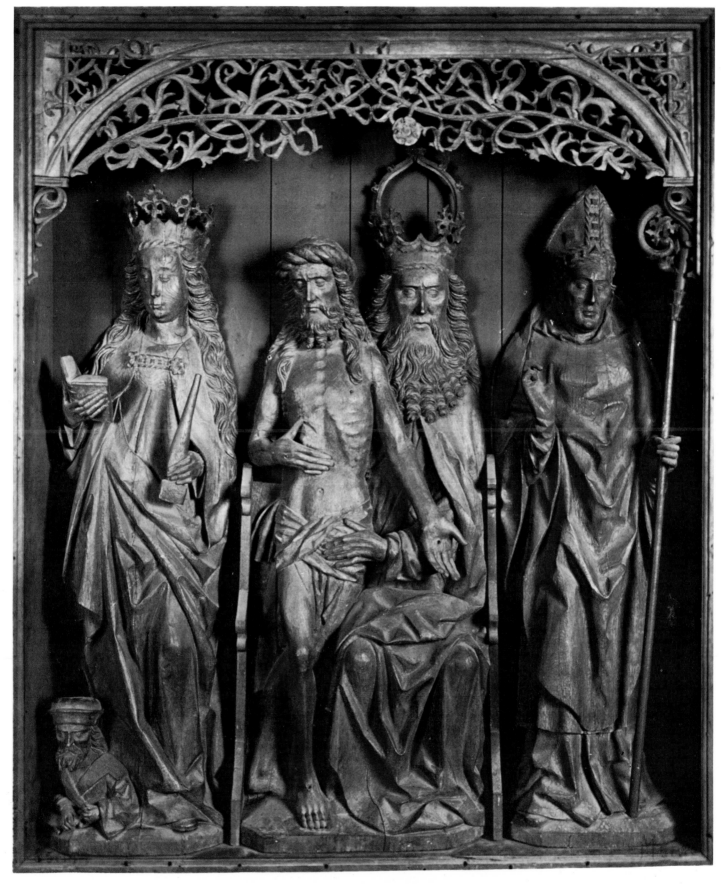

9. Altar of the Trinity with Saint Catherine and a Bishop Saint, North German, Lübeck, c. 1510–1520,
Circle of Bernt Notke, active c. 1490–1520, oak, 60 × 50½ inches.

Walter Cahn is Professor of Art History at Yale University.
Photographs. Colour: Herbert Vose; Nos. 1, 2, 5, 6, 8 and 9: Joseph Pratt; No. 4: James Austin.

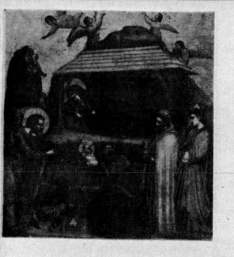

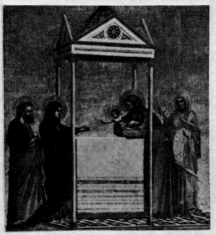

1. GIOTTO.
Seven scenes from the *Life of Christ*, c. 1320.
Adoration of the Magi, 17⅝ × 17½ inches.
The Metropolitan Museum of Art, New York.
Presentation of the Infant Jesus in the Temple,
17¾ × 17⅛ inches.
Isabella Stewart Gardner Museum, Boston.
Last Supper, 16¾ × 17 inches.
Alte Pinakothek, Munich.
Crucifixion, 17¼ × 17⅛ inches.
Alte Pinakothek, Munich.
Descent of Christ into Limbo, 17⅞ × 17⅛ inches.
Alte Pinakothek, Munich.
Entombment, 17¾ × 17¼ inches.
Berenson Collection, Florence.
Pentecost, 18 × 17⅜ inches.
National Gallery, London.

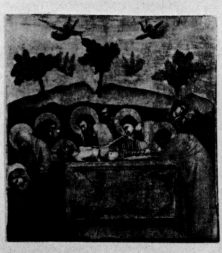

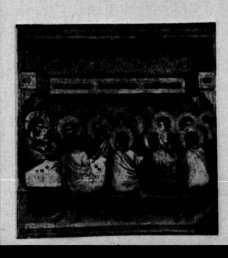

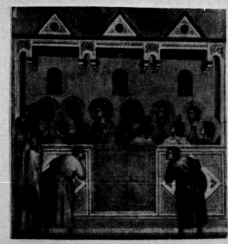

Italian Paintings at Fenway Court and Elsewhere

Everett Fahy

To a casual visitor walking through the splendid museum Mrs. Gardner created, it might not occur that some of the paintings are fragments. Mounted in gilt frames and hung on silk-covered walls, the paintings look more like independent works of art than isolated survivors from large *ensembles*. Our twentieth-century eyes see them in terms of the abstract qualities of their colour and decorative patterns. But if we consider them as parts of the larger works for which they were made, the paintings take on added meaning. It is only then that we can explain their curious shapes and begin to grasp some of the nuances of their style and subject matter.

At first glance the small painting of the *Presentation of the Infant Christ in the Temple* (colour A) looks like a self-contained object. It has a balanced composition: two pairs of standing figures flank a dainty ciborium which symbolises the Temple of Jerusalem. Following the Gospel of Saint Luke, the artist has illustrated the dramatic moment when the holy man Simeon and the prophetess Anna recognise the Christ Child as the Saviour.

Ever since the early nineteenth century, the *Presentation* has been known to be one of a series of seven paintings of the life of Christ (No. 1). In 1805 a *Last Supper*, now in the Alte Pinakothek in Munich, belonged to Crown Prince Ludwig of Bavaria. Eight years later a *Crucifixion* and a *Descent of Christ into Limbo*, both also now in Munich, were bought by Maximillian I. Four others formed part of the collection of Prince Stanislas Paniatowski who lived in Florence. The sale of his collection in 1839 included an *Adoration of the Magi* now in the Metropolitan Museum, an *Entombment* now in the Berenson Collection in Florence, a *Pentecost* in the National Gallery in London, and the Gardner *Presentation*. Other panels may have belonged to the series, but their existence seems not to have been recorded.

In the architecture of some of the scenes there are parallels for the curious decoration of the ciborium. The inlay of pink and dark blue stone recurs in the backgrounds of the *Last Supper* and the *Pentecost*. Moreover, the central placing of the ciborium is consistent with the symmetrical settings of the *Last Supper* and *Pentecost*. The three gables on the building in the *Pentecost* contain small rose windows similar to the ones decorating the ciborium in the Gardner painting.

Although some scholars have questioned the traditional attribution of the series to Giotto, all the scenes are devised with such imagination and executed with such depth of feeling that only he could have painted them. There is nothing stereotyped about the compositions: each action is expressive, each face is individual. Thus, in the *Presentation*, the Child struggles to get back in His mother's arms; in the *Adoration of the Magi*, Joseph looks with concern as the elderly King unexpectedly lifts the Child from the manger. None of Giotto's followers made such telling observations of human behaviour.

The mastery with which the figures are painted confirms Giotto's authorship of the panels. Even though they are comparatively small, the figures possess a statuesque grandeur, and certain ones such as the prophetess Anna bear comparison with the antique. What is perhaps most impressive about the series are its effulgent colours – pink, vermillion, orange, and chartreuse – which are far removed from the primary hues of Giotto's frescoes in the Arena Chapel and the conventional pastel shades of his students. The palette most closely approximates to that of the frescoes in the Peruzzi Chapel, and indeed the general character of the paintings is linked with this mature phase of Giotto's art. Translated from fresco to tempera, this style is enhanced by the pale green preparation of the panels. Unlike most gold ground pictures, which are executed over red bole, the series has a limpid tonality due to the underlying green pigment.

Since Saint Francis appears in the *Crucifixion*, it has been suggested that the series was commissioned for the Franciscan church of Santa Croce in Florence. According to Ghiberti, Giotto decorated four of its chapels. But neither the *Crucifixion* nor any of the other scenes contains details relevant to this particular church. The pictures might just as well derive from a panel painting that Giotto is said to have made for the town of Borgo Sansepolcro. By Vasari's time it had been cut into pieces, some of which had found their way into a Florentine collection where they were highly esteemed. Unfortunately, Vasari says no more about their appearance than that they consisted of small figures.

The notion that the series composed the predella of a polyptych – such as the dismembered one now divided between the National Gallery of Art in Washington, the Musée Jacquemart-André at Châalis, and the Museo Horne in Florence – is not very persuasive. The square format of the scenes is incompatible with the horizontal form of most predella panels. Nor do the compositions lead the eye from left to right, as is customary in narrative scenes painted for predellas. The seven panels tend to be symmetrical in design, and, if one side of the composition receives more emphasis than the other, it is the left: in the *Crucifixion* the Virgin swoons on the left, in the *Entombment* she collapses on the left, in the *Last Supper* Christ sits on the left, and in the *Pentecost* a mysterious figure stands outside on the left. Even in the square compartments under the Giottesque *Stigmatisation of Saint Francis* in the Louvre, the narrative moves inexorably from left to right.

If the seven panels did not come from a predella, the possibility exists that they were arranged vertically. They might, for example, have decorated the doors of a sacristy cupboard, like Taddeo Gaddi's quatrefoils now in the Galleria dell' Accademia in Florence. They might equally have formed part of a large tabernacle, like the one Taddeo's son Agnolo painted for the Florentine church of San Miniato al Monte. Or, disposed in two or more rows, one on top of the other, they might have originated as the compartments of a dossal like the one by a Paduan follower of Giotto in Miss Frick's new museum in Pittsburgh.

Although it is often stated that the seven panels are uniform in size, a close examination shows that this is not so. The widths of the panels are nearly identical. They fluctuate slightly, between 17 and $17\frac{3}{8}$ inches. But the heights vary from $16\frac{3}{4}$ to 18 inches. This difference suggests that when the panels were separated, they were cut longitudinally. Another shred of evidence that indicates the series was arranged vertically can be found on the backs of the panels. Those that I have seen once had vertical battens. On either side of the strip for the batten the wood was gessoed, covered with linen, and painted in tempera to resemble porphyry or coloured marbles. Perhaps the colouring will be the key for reconstructing the series.

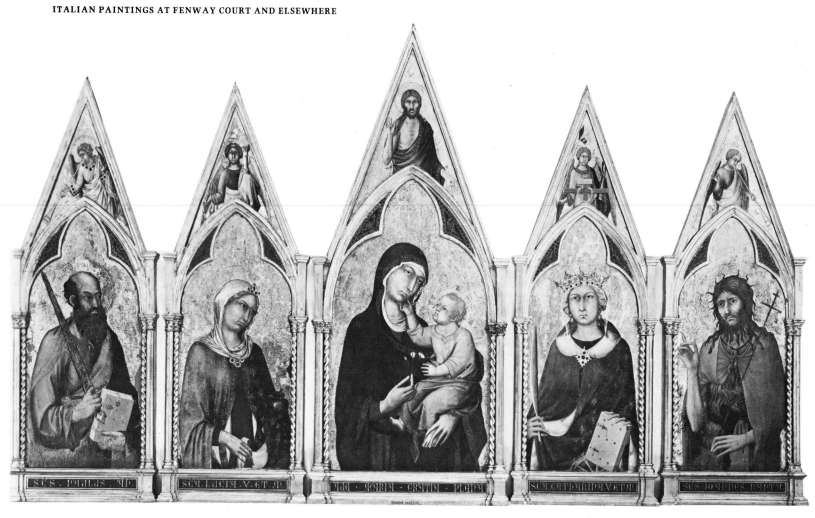

SCS · PAULUS · AP · SCA · LUCIA · V · ET · M · HOC · OPVS · FECIT · P · GICIA · SCA · MARGARITA · V · ET · M · SCS · JOHANES · BAPTA

SIMONE MARTINI

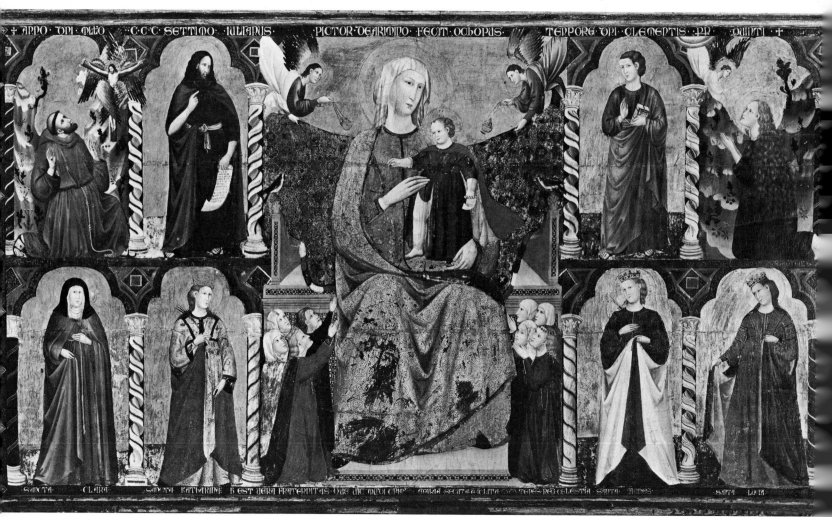

APPO · DNI · MCCC · SETTINO · IULIANUS · PICTOR · DEARIMINO · FECIT · OC OPUS · TENPORE · DNI · CLEMENTIS · PP · QUINTI

SANCTA · CLARA · SANCTA · KATHARINE · EST AERA FRATERNITAS · DNS · VIC · DVLCISSIMO · AVARA SECURA SICILIA · TENES REGO CELESTIA · SANTA · AGNES · SANTA · LUCIA

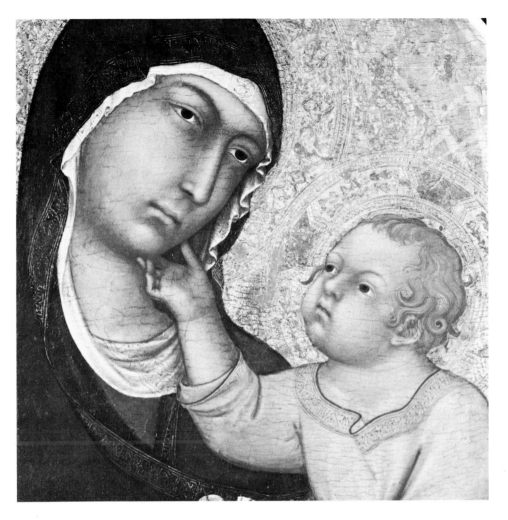

2. SIMONE MARTINI (1280/85–1344).
*Orvieto polyptych: Madonna and Child with four Saints,
Paul, Lucy, Catherine and John the Baptist,*
tempera and gold on wood, c. 1321.
Central panel: 39 × 23⅞ inches;
Laterals: 34 × 16⅞ inches.
Isabella Stewart Gardner Museum, Boston.

Above
3. SIMONE MARTINI.
Madonna and Child (detail of No. 2).

The evolution of the Italian altarpiece is well illustrated by several paintings in the Gardner Museum. The large panel by Giuliano da Rimini (No. 4) exemplifies the horizontal dossals that were common during Giotto's youth. In the centre is an enthroned Madonna accompanied by two flying angels and eight kneeling female donors. Eight full-length saints occupy the arched compartments arranged in two rows on either side of the Madonna. At the top an inscription with the artist's name and the date '1307' establish the dossal as the earliest signed work by a Riminese artist. During the first half of the fourteenth century, Rimini was the centre of a prolific school of painters who

4. GIULIANO DA RIMINI
(active 1307–died before 1346).
*Urbania Dossal: Madonna and Child
with eight Saints and eight Donors,*
tempera and gold on wood, dated '1307',
64½ × 119 inches.
Isabella Stewart Gardner Museum, Boston.

drew their inspiration from the Byzantine tradition and the innovations of Giotto. The Gardner dossal, which once belonged to the cathedral of Urbania, is an unusually well-preserved and decorative specimen of this provincial school.

The dossal has the added distinction of providing evidence for Giotto's chronology. Giotto worked at Rimini in 1313, but the painting reveals his influence there at least six years earlier. As several scholars have noticed, the *Stigmatisation of Saint Francis* in the upper left corner of the Gardner altarpiece is based on a fresco sometimes ascribed to Giotto in the Upper Church at Assisi. The spiral colonnettes and the figure of Saint Clare also seem to be copied from Giottesque frescoes in the same church. Since the date of these works is disputed, Giuliano's quotations provide historians with a concrete point of reference.

During Giotto's lifetime dossals became outmoded and a new type of altarpiece, the polyptych, took their place. As its name implies the polyptych consisted of several panels rather than the single one of the unified dossal. The change in structure brought with it a remarkable transformation in the way the Madonna was depicted. In place of the full-length Madonna such as we see in Giuliano's dossal, the Madonnas in polyptychs were shown as three-quarter-length standing figures. The viewer is thus brought closer to the Madonna, and her rôle as a mother takes precedence over her former guise as the awesome queen of

heaven. Giotto himself demonstrated the greater intimacy afforded by this format in his early polyptych now in the Uffizi, in Florence, and in the later one mentioned before, divided between Châalis, Florence, and Washington.

The only complete altarpiece by Simone Martini outside Italy is the Gardner polyptych, consisting of a Madonna standing with the Child in her arms, and a pair of male and a pair of female saints (No. 2). The framing elements are not altogether original, but their dynamic outlines suggest the Gothic form of the altarpiece. It was Simone's nature to exploit linear patterns for the utmost decorative effect. In the Gardner polyptych this aspect of his style manifests itself in the curvilinear folds of the drapery, the tight curls of the Child's hair, and the white headkerchief which envelops the Madonna's melancholy face (No. 3). There are five pinnacles at the top of Simone's polyptych. In the one over the Madonna, Christ displays the wounds in His hands. The others contain two angels with symbols of His passion and two sounding trumpets of the Last Judgment. In the same room we encounter a similarly shaped triangular panel, Ambrogio Lorenzetti's small painting of *Saint Elizabeth of Hungary.* Together with Ambrogio's delightful portrayal of *Saint Agnes*, it must have originally stood over a multi-panelled altarpiece like Simone's. Which one of Ambrogio's altarpieces this was has not been established. Because of the direction of the gazes, it is obvious that the saints stood on opposite sides of the polyptych and looked down towards a Madonna and Child (No. 10).

Early in the fifteenth century another type of altarpiece, the two-storied retable, came into vogue. Gentile da Fabriano's Valle Romita altarpiece, now in the Brera Gallery in Milan, is an early example of this type – which soon became popular in Venice and Padua. Mrs. Gardner's *Bishop Saint* (No. 5) by the Venetian Michele Giambono was cut down from one of these elaborate complexes. It showed an assembly of nine male saints, the most important being the Saint Michael now in the Berenson Collection at Florence. Seated on a throne, he would have occupied the centre of the main tier. Four saints stood beside him, and, above in the second story, there were four half-length saints. Mrs. Vavalà, who reconstructed the retable, considered placing over the central panel the *Man of Sorrows* by Giambono in the Museo Civico at Padua, but she decided against it because it has a light, rather than a dark, blue background. But in the accompanying photomontage (No. 7), the *Man of Sorrows* is inserted since its style and dimensions accord with the other panels and its gold halo is similar to those of the saints. Moreover, it shares the same provenance as the saints tentatively identified here as Gregory and Augustine, which were bequeathed in 1864 to the Padua museum by Count Capodilista. In the retable, the Gardner saint would have stood high above the viewer's head. As it is now displayed in the Early Italian Room of the museum, the viewer can enjoy it at eye-level. It bears out Mrs. Vavalà's statement that Giambono was 'a pleasant and delightful

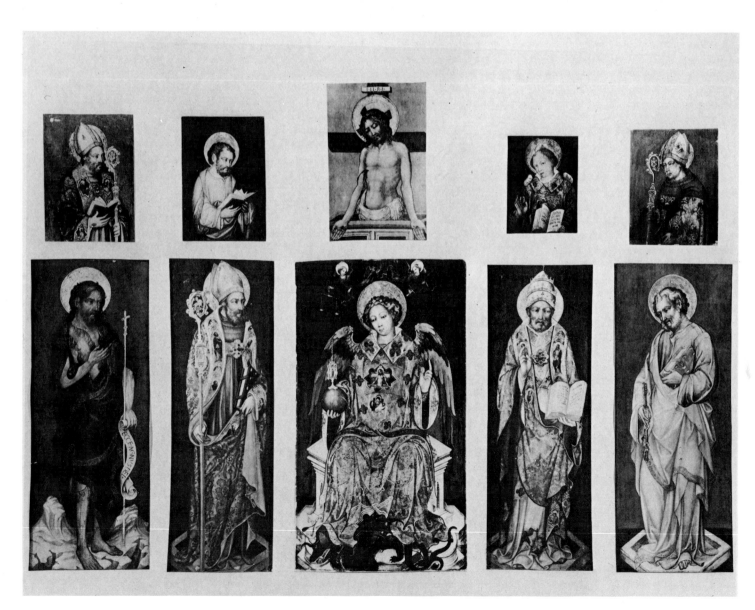

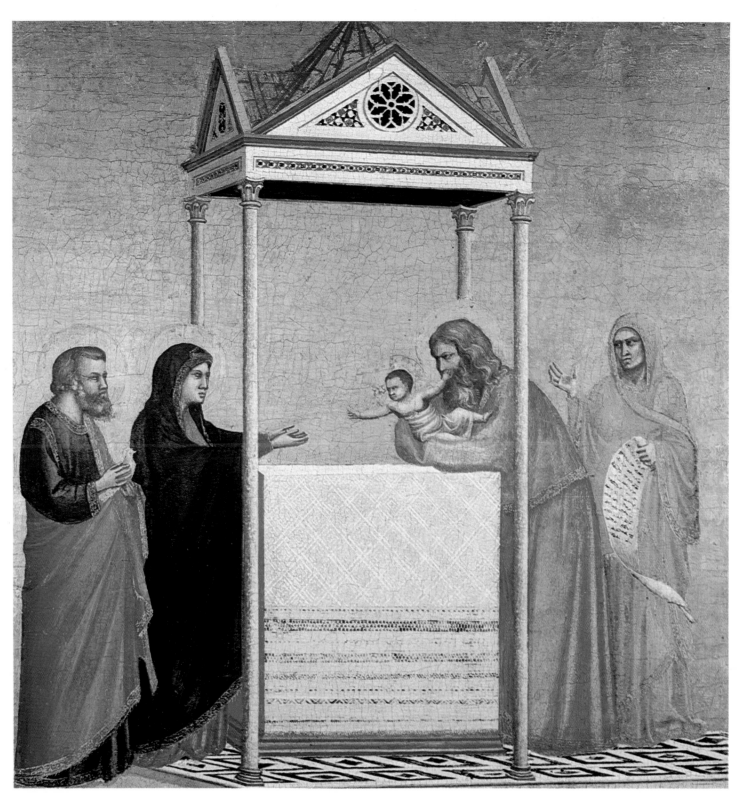

Top left.

5. MICHELE GIAMBONO (active 1420–1462).
A Bishop Saint, tempera and gold on wood,
c. 1450, 14¾ × 11¼ inches.
Isabella Stewart Gardner Museum, Boston.

Top right.

6. GIOVANNI DI FRANCESCO DA ROVEZZANO,
(1412?–1459).
Dormition of the Virgin, detail, tempera on wood.
Isabella Stewart Gardner Museum, Boston.

7. MICHELE GIAMBONO.
Reconstruction of the *Saint Michael Retable.*
Main tier: *Saint John Baptist*, 33½ × 13¾ inches.
Museo Bardini, Florence.
Saint Augustine (?), 33 × 9⅞ inches.
Museo Civico, Padua.

Saint Michael enthroned, 43¼ × 24⅝ inches.
Berenson Collection, Florence.
Saint Gregory the Great (?), 33 × 9⅞ inches.
Museo Civico, Padua.
Saint Peter, 33⅞ × 13¾ inches.
National Gallery of Art, Washington, DC.
Upper tier:
A Bishop Saint, 15¼ × 11⅜ inches.
Isabella Stewart Gardner Museum, Boston.
Saint Mark, 15⅛ × 11¼ inches.
National Gallery, London.
Man of Sorrows, 20 × 13⅜ inches.
Museo Civico, Padua.
Saint Stephen, 12¼ × 9 inches.
Gilbert Collection, Como.
A Bishop Saint, 14½ × 11⅞ inches.
Museo Civico, Padua.

A. GIOTTO (1266–1337).
Presentation of the Infant Jesus in the Temple,
tempera and gold on wood, *c.* 1320,
17¼ × 16¾ inches.
Isabella Stewart Gardner Museum, Boston.

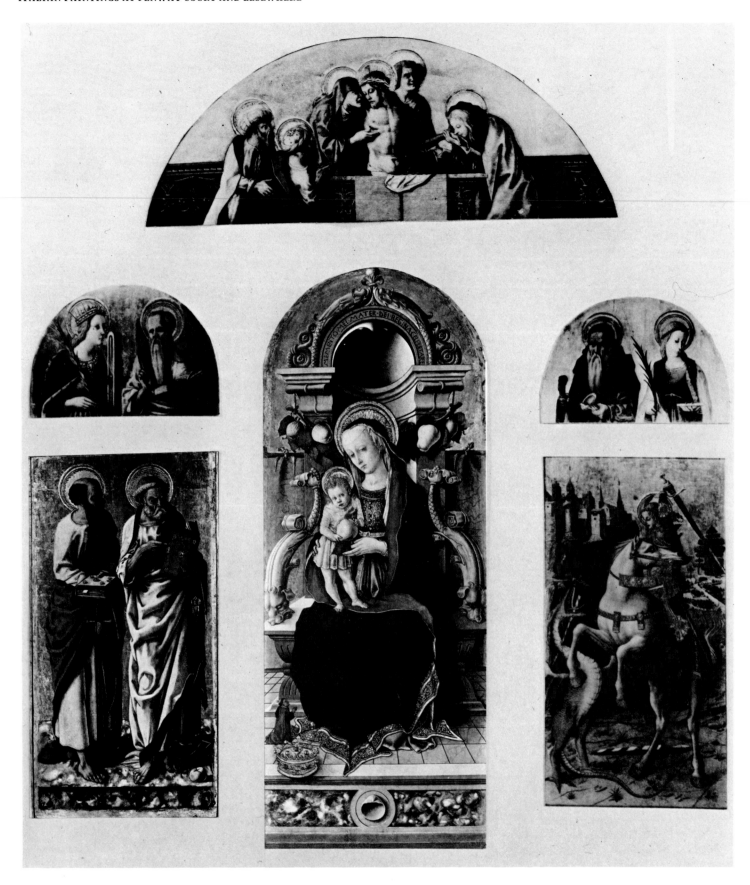

8. CARLO CRIVELLI
Reconstruction of the *Porto San Giorgio Retable*, 1470.
Main tier: *Saints Paul and Peter*, 36⅝ × 18½ inches.
National Gallery, London.
Madonna and Child enthroned, 51 × 21½ inches.
Samuel H. Kress Collection;
National Gallery of Art, Washington, DC.
Saint George and the Dragon, 37 × 18½ inches.
Isabella Stewart Gardner Museum, Boston.

Upper tier:
Saint Catherine of Alexandria and Jerome,
13⅞ × 19¼ inches.
Samuel H. Kress Collection;
Philbrook Art Center, Tulsa, Oklahoma.
Entombment, 16⅞ × 45 inches.
The Detroit Institute of Arts.
Saints Anthony Abbot and Lucy, 12½ × 16⅛ inches.
National Museum, Cracow.

figure, and his paintings, rare and slight, never
fail to evoke in the lover of things Venetian a
smile of welcome and pleasure, a grateful
thought for the delicate and lovable personality
they reflect'.

Charged with excitement and bristling with
spikey forms, the *Saint George and the Dragon*
(front cover) is one of Carlo Crivelli's master-
pieces. Although the artist worked for more

34

than thirty years after painting it, he never again produced anything quite so full of vigour and imagination. What could be more dramatic than the contrast between the rearing horse, its head distorted with fear, and the tender saint, his eyes fixed on the dragon he is about to slaughter? Crivelli's saint is no robust hero, but a slim boy who must use all his might to wield his heavy sword. The jutting shapes of his armour are echoed in the towers of the hill town in the background. On a cliff just below it, kneels the tiny figure of the princess who was to be the dragon's next victim.

Few paintings in the Gardner Museum are more self-sufficient. Yet Crivelli's *Saint George* originated as part of a multi-storied retable (No. 8). Thanks to an early nineteenth-century guidebook, six parts of it can be identified. The central panel was the *Madonna and Child Enthroned*, now in the National Gallery of Art in Washington. Balancing the *Saint George* on the other side of her was a single panel with *Saints Paul and Peter*, now in the National Gallery in London. Crowning the altarpiece were three lunettes, which belong to museums in Cracow, Detroit, and Tulsa. Crivelli made the retable for the parish church of Porto San Giorgio, a village near Fermo in the Marches. It was commissioned by an Albanian immigrant, Giorgio Salvadori, whose portrait appears in the Washington panel. Since his patron saint was George, it is not surprising to see that Crivelli lavished his talents on the extraordinary panel now at Fenway Court.

In looking at photographic reconstructions of dismembered altarpieces, such as the Giambono and Crivelli retables (Nos. 7 and 8), it is important to bear in mind that the paintings were housed in large wooden frames. These were gilded and carved with strong architectural motifs that united the separate panels into a harmonious *ensemble*.

The long rectangular *Dormition of the Virgin* in the early Italian Room served as the predella of a large altarpiece (No. 9) that once stood in the church of San Giovanni Evangelista at Pratovecchio. The central panel completed the subject of the predella with a large depiction of the Virgin's *Assumption*. To the sides were four standing saints, which are now preserved in London along with over a dozen small panels which decorated the pilasters and pinnacles. The Gardner panel is rather large in relation to the other panels, but given the provincial origin of the altarpiece and the rather eccentric character of the artist who painted it, this is not surprising. For years the artist was called the Master of Pratovecchio, after the town where the *Assumption* was found. Berenson tentatively identified him with Giovanni di Francesco, a minor artist who Vasari claimed was a pupil of Castagno's (and indeed the figure style of the *Dormition* shows his influence [No. 6], just as the design of the central panel derives from Castagno's *Assumption* of 1449/50 in the Gemäldegalerie at Berlin). Shortly after Berenson died, a document came to light which confirmed his intuition.

9. GIOVANNI DI FRANCESCO.
Reconstruction of the *Pratovecchio altarpiece*,
c. 1450.
Saints Michael and John Baptist, 37 × 19½ inches.
National Gallery, London.
Assumption of the Virgin, 34⅝ × 22⅞ inches.
San Giovanni Evangelista, Pratovecchio.
A Bishop Saint and a female Martyr, 37 × 19½ inches.
National Gallery, London.
Predella:
Dormition of the Virgin, 13 × 75³⁄₁₆ inches.
Isabella Stewart Gardner Museum, Boston.

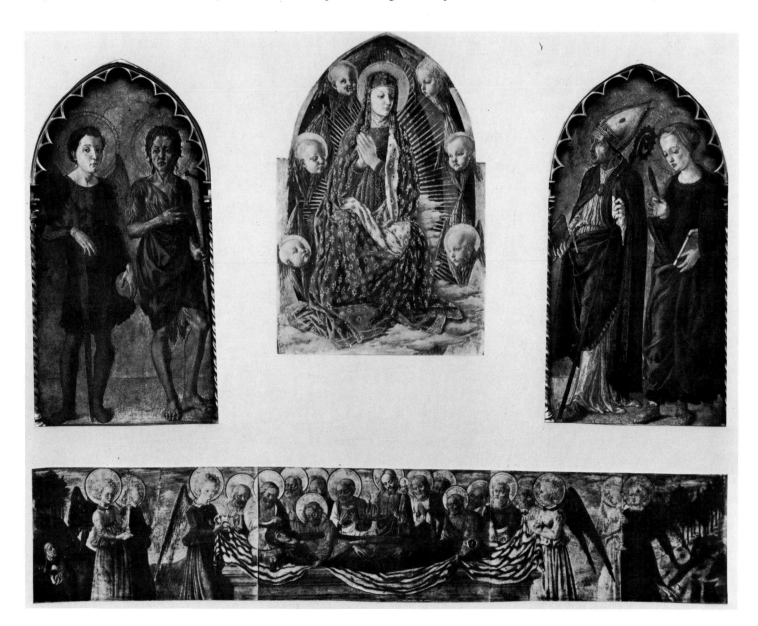

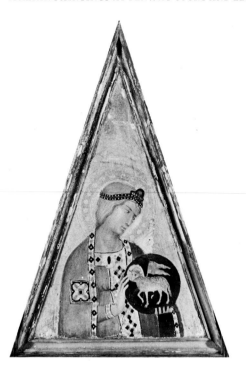

10. AMBROGIO LORENZETTI
(active 1319–1348/9).
Saint Agnes, c. 1330, tempera and gold on wood,
12½ × 8½ inches.
Fogg Art Museum, Cambridge, Massachusetts.

AMBROGIO LORENZETTI.
Saint Elizabeth of Hungary, c. 1330,
tempera and gold on wood, 14¾ × 9⅞ inches.
Isabella Stewart Gardner Museum.

B. RAFFAELLO SANTI. (1483–1520).
Lamentation over the dead Christ,
tempera on wood, *c.* 1505, 9 × 11 inches.
Isabella Stewart Gardner Museum, Boston.

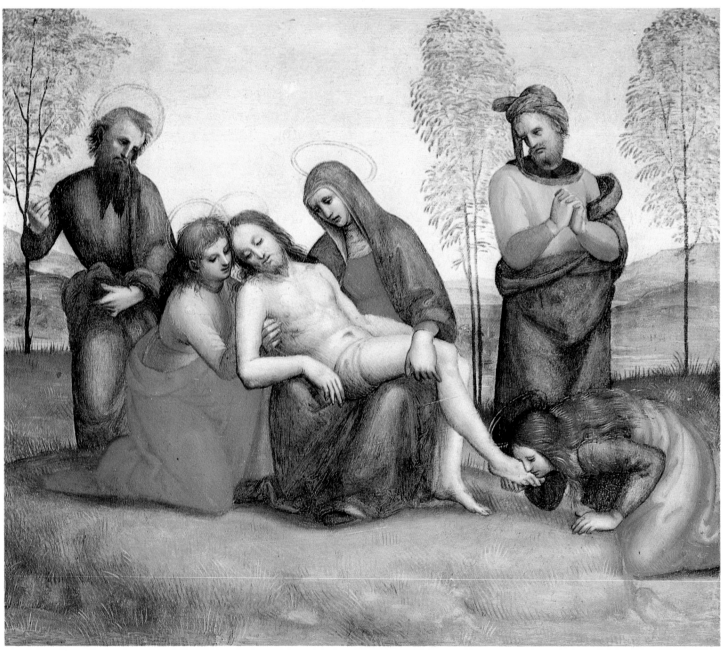

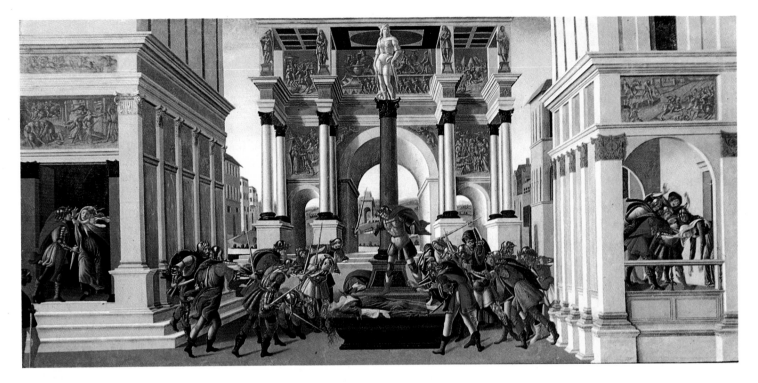

c. SANDRO BOTTICELLI (1445–1510).
Tragedy of Lucretia, tempera and oil on wood,
c. 1505, 32¾ × 70¼ inches.
Isabella Stewart Gardner Museum, Boston.

11. SANDRO BOTTICELLI.
Story of Virginia, tempera and oil on wood,
c. 1505, 32¼ × 65 inches.
Accademia Carrara, Bergamo.

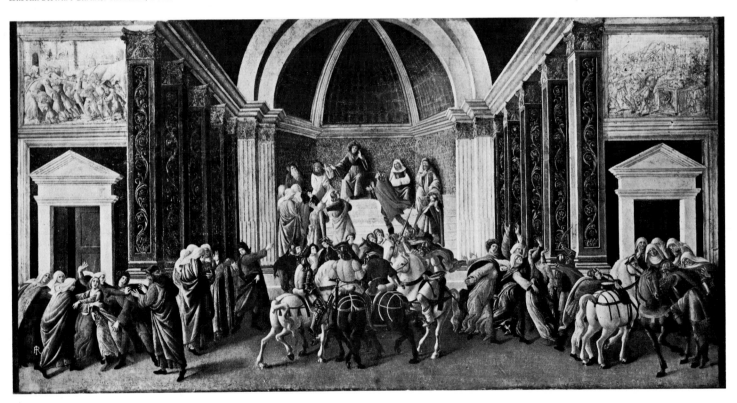

Although the original function of Cosimo Tura's *Circumcision* (No. 12) is not known, the painting was clearly once part of a larger whole. A circular painting, it recalls the *tondos* on which the Madonna and Child and occasionally the Adoration of the Magi were depicted in Italy during the fifteenth century. But the Gardner roundel is a narrative scene that was never intended to be seen in isolation. In size, shape, and subject matter it is linked to Tura's paintings of the *Adoration of the Magi*

(No. 13) and the *Flight into Egypt* (No. 14). If other roundels belonged to this series, they are not recorded. The two roundels by Tura in the Pinacoteca at Ferrara are larger and survive from an altarpiece devoted to Saint Maurelius.

It has been proposed that Tura's roundels were part of the decoration of a baptismal font or of a wedding chest, suggestions that can neither be proved nor disproved. It has also been connected with the *Madonna and Child enthroned with six Angels*, which was commis-

sioned about 1480 from Tura by the Roverella family (No. 15). With its crumpled drapery and nearly symmetrical figures, it displays on a large scale the mannered style of the Gardner panel. The Roverella *Madonna* also contains two tablets with the Ten Commandments that bear a strong resemblance to the tablet on the altar in the Boston panel. In the place of the Hebrew lettering seen in the London painting, the tablet in the *Circumcision* shows Moses kneeling in prayer. How the roundels might

37

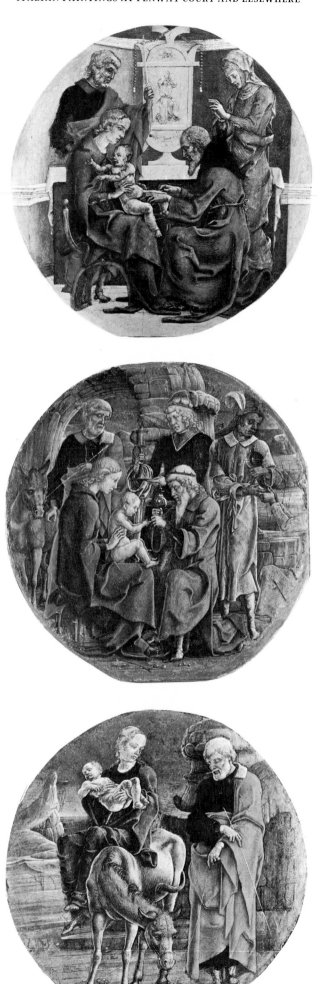

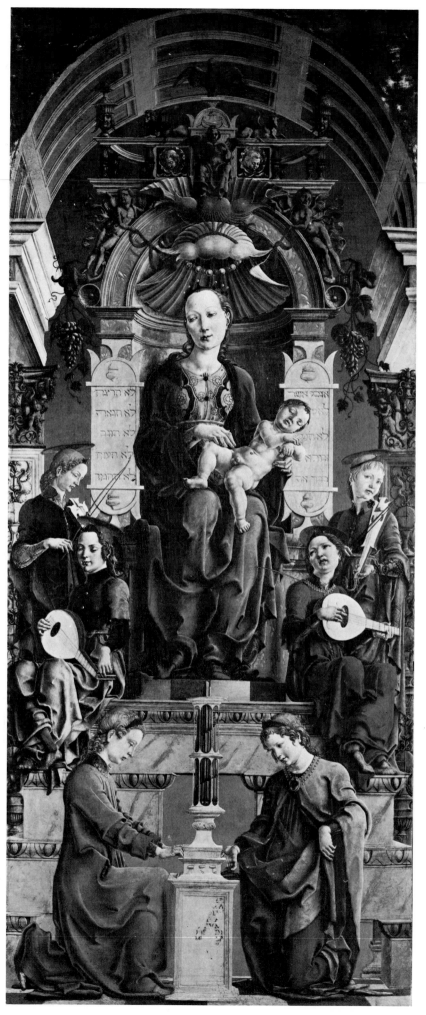

Far left, top.
12. COSIMO TURA
(*c.* 1430–1495).
Circumcision,
tempera on wood,
c. 1480, 15¼ × 15 inches.
*Isabella Stewart Gardner
Museum, Boston.*

Far left, centre.
13. COSIMO TURA.
Adoration of the Magi,
tempera on wood,
c. 1480, 15⅜ × 15 inches.
*Fogg Art Museum,
Cambridge, Massachusetts.*

Far left, below.
14. COSIMO TURA.
Flight into Egypt,
tempera on wood,
c. 1480, 15 × 15 inches.
*The Metropolitan Museum
of Art, New York.*

Left.
15. COSIMO TURA.
*Madonna and Child
enthroned with six Angels,*
central panel of the Roverella
altarpiece, *c.* 1480,
tempera on wood,
94 × 40⅛ inches.
National Gallery, London.

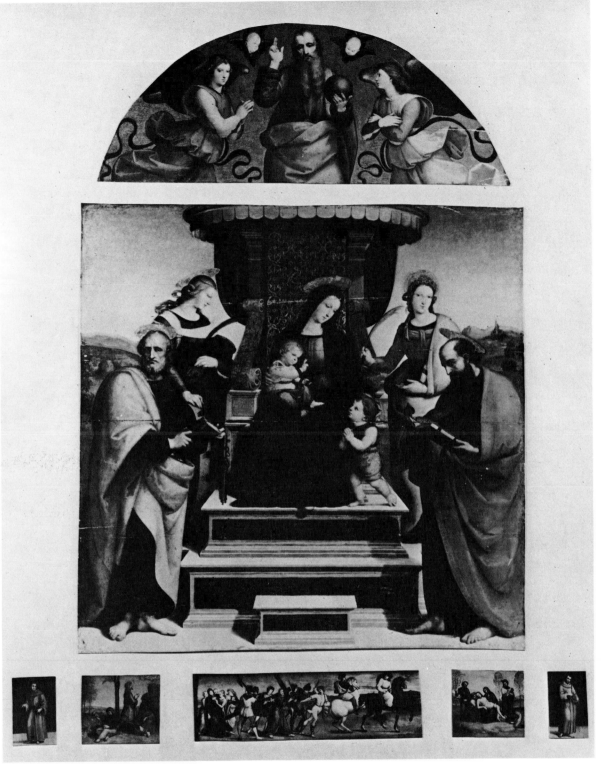

16. RAFFAELLO SANTI.
Reconstruction of the *Colonna altarpiece, c.* 1505.
*Madonna and Child enthroned with the young Saint John
and Saints Peter, Catherine, Cecilia, and Paul,* 66½ × 66⅛ inches.
The Metropolitan Museum of Art, New York.
Lunette. *God the Father between two Angels,* 28¾ × 66⅛ inches.
The Metropolitan Museum of Art, New York.
Predella. *Saint Anthony of Padua,* 10¼ × 6¼ inches.
Dulwich College Picture Gallery, London.
Agony in the Garden, 9½ × 11½ inches.
The Metropolitan Museum of Art, New York.
Procession to Calvary, 9½ × 33½ inches.
National Gallery, London.
Lamentation over the Dead Christ, 10¼ × 6¼ inches.
The Metropolitan Museum of Art, New York.
Saint Francis, 10¼ × 6¼ inches.
Dulwich College Picture Gallery, London.

have been incorporated in the Roverella altar-piece is difficult to imagine. The notion that they formed part of the predella is refuted by an eighteenth-century description, in which the lives of Saint Benedict and Bernard are said to have been illustrated. The roundels might have been engaged in the frame, but as they are so exquisitely painted it is unlikely they would have been placed very high.

A perfect example of a predella panel is Raphael's *Lamentation over the dead Christ* (colour B). Together with a panel of the same size depicting the *Agony in the Garden* and a long rectangular *Procession to Calvary,* it stood in the base of the so-called Colonna altarpiece which was commissioned by the nuns of

39

D. TITIAN (1477/90–1576).
Rape of Europa, detail of No. 17.
Isabella Stewart Gardner Museum, Boston.

Sant'Antonio at Perugia. The main panel, with the Madonna and Child enthroned with saints, and the lunette, with God the Father between two angels, now belong to the Metropolitan Museum. Two small upright panels are closely related in style, and may have belonged to the altarpiece as well. They depict Saints Anthony of Padua and Francis. Slightly smaller than the three predella panels, they may have stood under the pilasters that framed the main panel.

In the design of the Gardner *Lamentation*, Raphael took into account the position it occupied at the right end of the predella. He deliberately arranged the figures to suggest a diagonal which ascends from the lower right corner to the upper left corner. Beginning with the crouching figure of the Magdalen, and rising through Christ's inclined body, it culminates in the bearded head on the left. This diagonal is counterbalanced in the composition of the *Agony in the Garden* at the other end of the predella. Here the diagonal moves in the opposite direction, upward from the seated apostle in the lower left corner, through Christ's praying hands, to the angel in the upper right corner. Above, in the main panel, these diagonals are continued in the perspective of the steps of the throne and paralleled by the larger diagonals created by the heads and shoulders of the saints and the inclined bodies of the angels at the top. When the Gardner panel is seen by itself, its diagonal organisation may not be particularly evident since the scene is so harmoniously composed. Yet the more one considers the panel in relation to the entire altarpiece, the more ingenious Raphael's design can be seen to be. Even the way the Virgin's body is turned towards the left complements the diagonal axis (No. 16).

E. GIOVANNI BATTISTA TIEPOLO (1696–1770).
The Wedding of Barbarossa,
1750, $27\frac{3}{4} \times 21\frac{1}{4}$ inches.
Isabella Stewart Gardner Museum, Boston.

Near Raphael's *Lamentation* hangs a contemporary work by Botticelli, his stirring portrayal of the *Tragedy of Lucretia* (colour c). Like the other pictures discussed in this article, it is part of a larger *ensemble*. But whereas the others have religious subjects and were commissioned for churches, Botticelli's panel has a secular theme and comes from the decoration of a Florentine house. In his life of Botticelli, Vasari alludes to a series of panels by the artist that were set into the wainscoting of a room in a house the Vespucci owned. Although Vasari does not specify their subjects, these panels must have included the Gardner *Lucretia* because its date coincides with Guidantonio Vespucci's purchase in 1499 of a house in the via dei Servi. Guidantonio's son, Giovanni, married the following year, and it is generally assumed that he enlisted Botticelli to paint the panels for his bride. The theme of female virtue exemplified in the Gardner painting also dominates the other surviving piece of the room's decoration, the *Story of Virginia* (No. 11) in the Accademia Carrara at Bergamo. By coincidence the Fogg and Worcester museums possess mythological scenes by Piero di Cosimo which were painted about the same time for the same patron. Vasari, who is our only authority for this information, saw them in the Vespucci house.

The two panels by Botticelli, which are about the same size, are also related in having monumental architectural backgrounds. In the Gardner panel the Arch of Constantine and the classical buildings on the sides recall Vitruvius's formula for the setting of tragedies. In the middle distance typically Florentine buildings can be seen. The vast basilica that forms the setting for the painting at Bergamo combines classical motifs with a vaulted apse based on Brunelleschi's cupola of Florence cathedral. In both paintings the architecture unifies the various episodes of each narrative.

Botticelli seems to have laid special emphasis on the political connotations of the stories. The central event of the *Tragedy of Lucretia* is Brutus' vow to overthrow the Tarquin kings. In the pendant at Bergamo the agitated horsemen in the centre swear a similar oath of revenge. These strong republican sentiments may have been inspired by the short-lived attempt to establish a republic in Florence after the expulsion of the Medici.

Titian's masterpiece, the *Rape of Europa* (colour D and No. 17) was one of seven mythological canvases painted for Philip II of Spain. They were executed in Venice during the 1550s and shipped to Spain between 1559 and 1562. In April of the latter year Titian wrote to Philip: 'With the help of divine providence, I have at last finished the two pictures already commenced for your Catholic Majesty. One is the "Christ Praying in the Garden", the other the "Poesy of Europa Carried by the Bull", both of which I send'.

It is not known where Titian's *poesie* were hung. The year after he sent the *Europa*, Philip II moved his residence and court to Madrid. It was not however until a century later that we

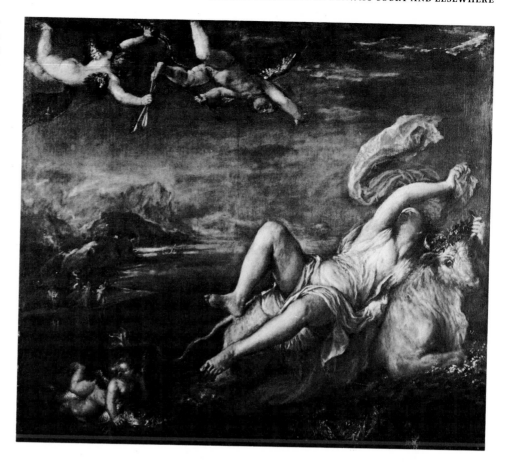

hear about the location of the mythologies. According to the royal inventories of 1668, 1686, and 1700, they hung in the Alcáza at Madrid, in a room known as the Bovedas de Ticiano. One might imagine they were displayed like the large canvases by Rubens and Jordaens visible in the background of Velázquez's court portrait, *Las Meninas*.

17. TITIAN.
Rape of Europa,
1559–1562, 70 × 80½ inches.
Isabella Stewart Gardner Museum, Boston.

18. TITIAN.
Perseus and Andromeda,
1554–1562, 72 × 78¾ inches.
Wallace Collection, London.

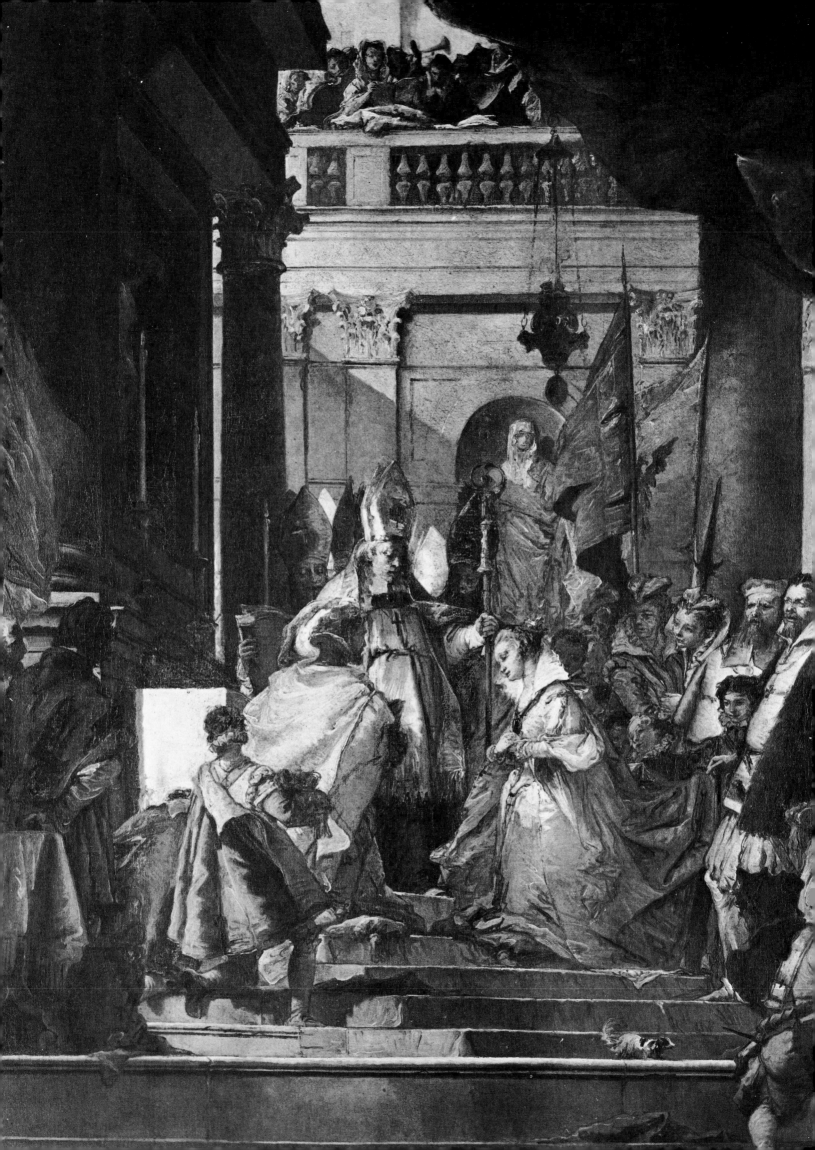

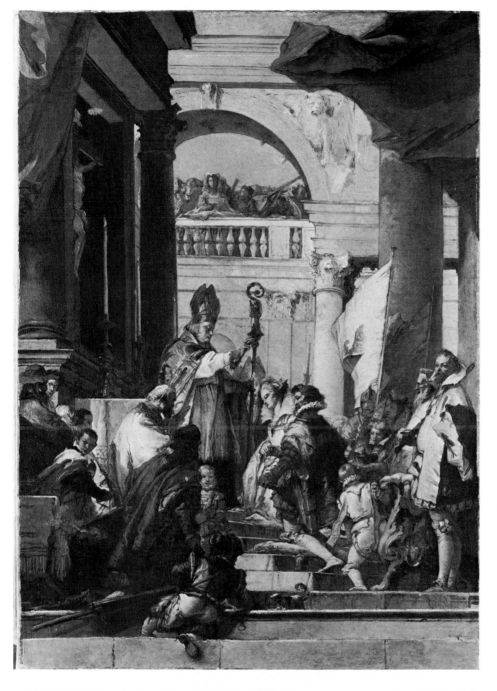

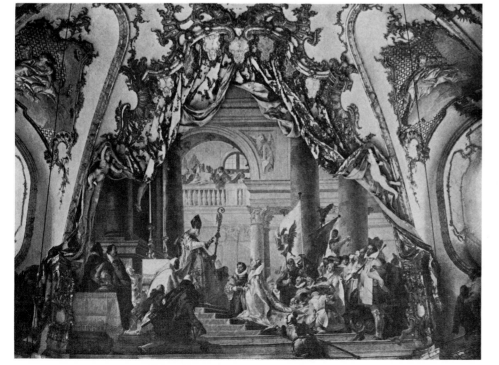

Far left.
19. GIOVANNI BATTISTA TIEPOLO (1696–1770).
The Wedding of Barbarossa,
1750, 27¾ × 21¼ inches.
Isabella Stewart Gardner Museum.

20. DOMENICO TIEPOLO (1727–1804).
The Wedding of Barbarossa,
c. 1751, 28½ × 20¾ inches.
National Gallery, London.

To judge from the different formats of the seven mythologies, Titian did not design them for a specific place. Yet one of the canvases, the *Perseus and Andromeda* now in the Wallace Collection (No. 18), looks as if it were a pendant to the *Europa*. Both are wide seascapes, both depict heroic females in distress, and both have winged figures in the sky. Even if they were not planned as a pair, their affinity cannot be denied.

Tiepolo's lovely sketch of the *Wedding of Barbarossa* (No. 19) is a study for the decorations of the Kaisersall in the Residenz, the archbishop's palace, at Würzburg. It was commissioned during the summer of 1750 by the Prince-Bishop Karl Philipp von Greiffenklau who assigned the subjects, events from the life of the Holy Roman Emperor Frederick Barbarossa (1150–1190). On the ceiling the Emperor is shown being led by Apollo to his bride, Beatrice of Burgundy. On the walls, or rather in the curved cove below the ceiling, are large scenes of Barbarossa's wedding and his investiture of the Prince-Bishop Harold von Hochheim with the Duchy of Franconia (No. 21).

The Gardner canvas is a sketch Tiepolo prepared in Venice before he left for Würzburg. Its upright vertical format had to be revised for the broad, irregular space allotted for the fresco. The steps were lengthened, many figures were added, and the three principals were rearranged: instead of standing between the betrothed, the officiating bishop is shown in profile and the Emperor kneels behind his bride so that he may face the spectator. A sketch in the National Gallery in London (No. 20) incorporates elements of both the Gardner canvas and the finished fresco. It must have been painted at Würzburg because, as in the fresco, the bishop is now in the likeness of Karl Philipp von Greiffenklau. Most experts believe it was executed as a souvenir by Tiepolo's precocious son, Domenico. About the authorship of Mrs. Gardner's sketch there are no doubts. It is a superb presentation piece, fit for a prince.

Photographs.
Colour A–E: Herbert Vose;
Nos. 3–6, 9: Joseph Pratt.

*Everett Fahy is Director
of The Frick Collection, New York.*

21. GIOVANNI BATTISTA TIEPOLO.
The Wedding of Barbarossa, fresco, 1751/2.
Residenz, Würzburg.

Classical Art

Cornelius Vermeule

The Greek and Roman antiquities at Fenway Court are all the more impressive because they have never loomed large in the history and mythology of Mrs. Gardner's collecting. They are mostly marbles of the traditional sort, acquired for decorative purposes from old collections and excavations in Italy, chiefly the area around Rome. Charles Eliot Norton's son Richard gave advice and help from Italy, but many sculptures appear to have arrived amid the cargoes of Italian stone and architectural carvings imported during the construction of the palazzo. That there are masterpieces among the marbles not widely noticed until the last two decades makes ancient art an aesthetic dividend for those visiting the Renaissance pictures or the literary souvenirs of late Victorian and Edwardian Boston. Most of these sculptures are grouped in or near the great central court, although there are several herms and busts in a gallery on the upper floor and fragments of sarcophagi are to be seen in the gardens, let into the walls in the approved Italian fashion. The floor mosaic of Hadrian's age, the second quarter of the second century of the Empire, has been set most naturally in the centre of the central court, not unlike the place for which it was originally designed. Finally, there are a few Greek and South Italian vases, Romano-Campanian painted wall-fragments, small marbles, and minor bronzes to be found on the tables or in the corners of the rooms devoted to the greatest Quattrocento and later paintings.

L IKE Sir John Soane's Museum, in many ways London's late Georgian and Regency counterpart to Fenway Court, the collection is rich in marble cinerary chests or urns. These rectangular boxes with pedimental lids (like miniature mausolea) or circular containers with conical covers (successors to Etruscan hut-urns) were elaborately carved with decorative motifs and suitably inscribed to contain the ashes of Romans from all walks of life in the century and a half from Julius Caesar to Hadrian. They were placed in niches in the underground vaults or *columbaria* just outside the traditional limits of the city, and they were unearthed in considerable numbers from the Renaissance onwards. Collectors, like Sir John Soane and Isabella Stewart Gardner, with a taste for decorative and literary antiquities in surprising architectural settings found cinerary urns admirably suited to their creative aspirations. Thus, the visitor to Fenway Court finds a number of these marbles between the colonnettes and beside the benches in the cloisters between the central court with its major statuary and mosaic and the gardens outdoors.

The connoisseur visiting the Gardner Museum will always enjoy the Greek and Roman marbles for the pleasure of their settings, the way Mrs. Gardner intended they should be seen. The specialist in Greek sculpture and its ancient Roman survivals will doubtless find other equally interesting masterpieces beyond the examples discussed and illustrated in these pages. Among those to be noticed on a tour of the collections but not considered here are the Graeco-Roman marble throne from near Beneventum, the statue of

Artemis or an Amazon after a famous figure of *c.* 400 to 375 BC (this Pentelic marble copy found at Tusculum) and the garland sarcophagus for a Roman child, a carving created in western Asia Minor *c.* 250 AD and exported to Rome shortly thereafter for sale to the family of the deceased. These three sculptures are in the central court (colour A, page 2).

The most famous statue at Fenway Court is probably the Gardner 'Peplophoros', a representation of a youthful goddess such as Persephone, made in the time of Julius Caesar or Augustus after an original of *c.* 455 BC (colour A). The smooth finish of the surfaces and the translucent qualities of the Greek island marble make this a very attractive modernisation of a bronze from the so-called 'Severe Style' which led to the golden age of Phidias and the Parthenon in Athens. The goddess, or perhaps a noble mortal, wears a high-girt Doric chiton with an ample overfold. The chiton is represented as sewed at the right side, where a long wavy seam with horizontal stitches has been carefully copied in marble from the bronze original. Mrs. Gardner's treasure of Greek female dignity was discovered in March 1901, on the site of the famous Gardens of Sallust, in the property of the Sisters of San Giuseppe between the Via Lucullo and the Via Sallustiana on the Pincian Hill. Mrs. Gardner never saw the statue in Boston. After her purchase of the find through Richard Norton it was a showpiece of the American Academy in Rome from 1901 until 1936, when the Italian government authorised its export.

Another statue of a draped female at Fenway Court was acquired at the same time, perhaps from a find in the same region of Rome, and is a late Hellenistic to early Roman imperial version of a Praxitelean funerary figure of *c.* 340 BC (No. 1). Again the goddess Persephone or a noble lady in very ideal form may have been represented. Also carved of marble from Paros or Naxos in the Aegean island chain which produced the finest stone for statuary in Antiquity, the woman is clothed in a long chiton covered by an ample himation, both arranged to suggest the contours and pose of the body beneath. Praxiteles was celebrated among ancient authors for his creation of beautiful women in the nude, chiefly the Aphrodite at Knidos for which the sculptor's mistress Phryne served as model, but he also fashioned statues of more modest females such as Artemis, her mother Leto, and her nieces the Muses. It was Praxitelean draped beauty (and the city of Kos across the water from Knidos owned a fully-clothed Aphrodite by the master) which appealed to Mrs. Gardner's tastes and standards in Greek sculpture. The Praxitelean goddess or lady of fashion brought to Boston at the outset of the Edwardian decade suited these aspirations to classical perfection.

1. Goddess (Persephone?) or Woman,
Greek, first century BC or AD,
after a work of *c.* 350 BC,
Greek island marble.
Height: 59½ inches.

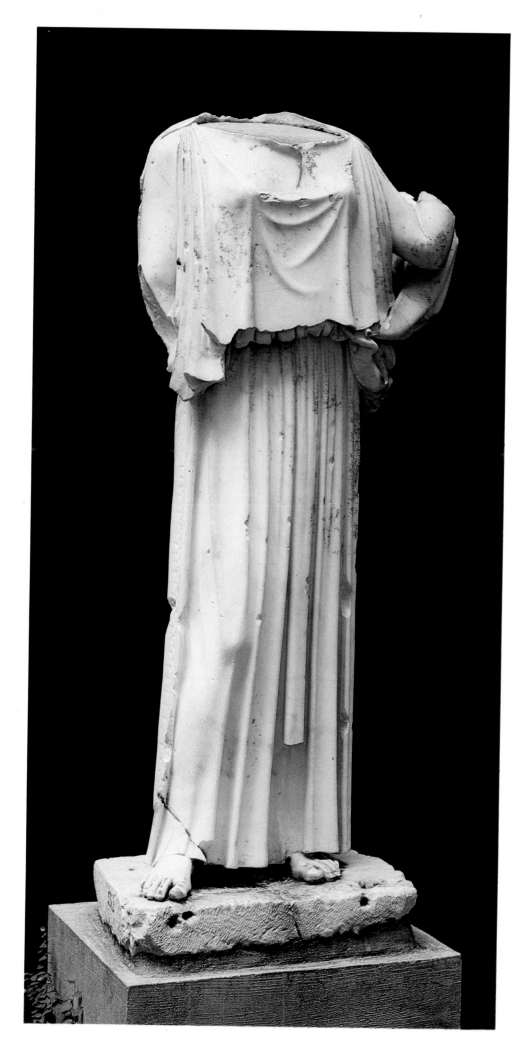

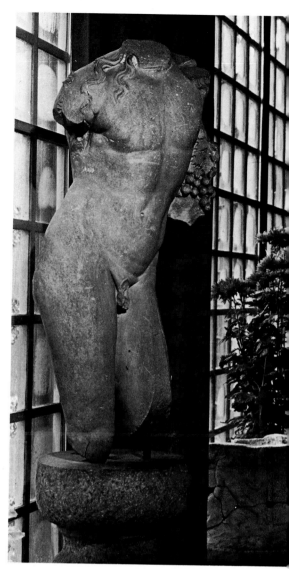

2. Torso of Dionysos,
Graeco-Roman, Antonine period (140–190 AD),
marble.
Height: 36¼ inches.

Of the variety of figures of the Greek gods and heroes set about Fenway Court, the finest is a torso of Dionysos in the youthful, ideal traditions of the Hermes or satyr with the infant Dionysos after Praxiteles (No. 2). The god with his soft, relaxed physique leans against a vine-stump support, and there are the traces of a fillet, from a wreath, on the right shoulder. The use of the drill in defining the leaves and grapes suggests that this copy was carved in the Antonine period of the Roman Empire, between 140 to 190 AD. The most famous series of statues in this pose involving a Praxitelean youth leaning in exaggerated fashion against a tree was the Apollo Sauroktonos (Lizard-Slayer), known in numerous Graeco-Roman marble copies of a lost bronze by the master. Praxiteles could vary this pose for Apollo, for Nathaniel Hawthorne's *Marble Faun*, or for the Dionysos seen here.

A. 'Peplophoros', Graeco-Roman,
copy of a work of *c*. 455–450 BC,
marble.
Height (without plinth): 58¼ inches.

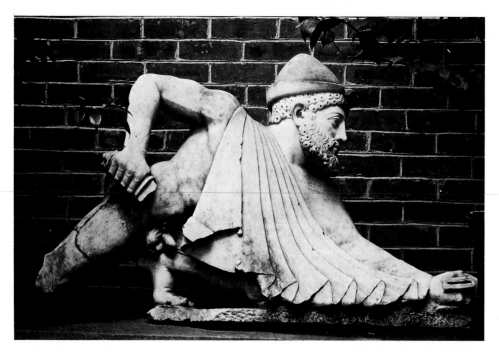

3. Odysseus creeping forward during
the Theft of the Palladium,
Graeco-Roman, *c.* 50 BC, in the style of 490 BC,
Pentelic marble.
Height: 25¼ inches.

The most unusual, most surprising statue at
Fenway Court has overtaken the Gardner
'Peplophoros' in art-historical popularity in
recent years. This is the Pentelic marble figure
of Odysseus creeping forward during the theft
of the Palladium from Troy (No. 3). He is an
Archaistic work, a Graeco-Roman carving of
about 50 BC in the style of 490 BC or the end of
the true age of Archaic Greek art. The figure's
peculiar pose suggests that it could have been
copied from a composition designed for the
narrowing angle of the pediment of a late-
Archaic Greek temple. The statue, like the
'Peplophoros', also once adorned the Gardens
of Sallust in Rome, perhaps as part of a group
with Diomedes (companion in the mythologi-
cal adventure) in a garden *exedra*. Odysseus
was found in September 1885, on the property
of Giuseppe Spithoever (the famous Villa
Spithoever, source of so many famous anti-
quities), and purchased by Mrs. Gardner
through Richard Norton in 1898. Two great
figures in the Risorgimento of Italian ar-
chaeology, R. Lanciani and C. L. Visconti,
reported on the discovery, but Archaistic sculpture
was not fashionable in the 1920s on up to
the 1950s, and Odysseus was allowed to creep
back into oblivion on a shelf at the back of the
central court in Mrs. Gardner's palace. (For
years his best view was only for those visiting
the gentleman's washroom at Fenway Court.)
Despite records of excavation and the blessings
of Professor Lanciani, well-known in Mrs.
Gardner's time on the lecture circuit in Boston,
there were those who dubbed Odysseus 'The
Billiard Player' and suggested he was a forgery
in the taste and traditions of Dossena. In 1954
the late Vagn Poulsen of the Ny Carlsberg
Glyptotek, Copenhagen, published a major
rehabilitation, 'Odysseus in Boston', and since

then the crafty old ruler of Ithaca with his
characteristic conical cap has scrambled back
into both more prominent view at Fenway
Court and popular, illustrated literature about
the Trojan Wars and their aftermath.

The cinerary urn well worth noting is the
example carved in Pentelic marble *c.* 100 AD
and inscribed by Publius Ciartius Alexander to
his dearest brother Publius Ciartius Iasus (No.
4). The plaque with this fraternal recording is
flanked by rams' heads from which hangs a
garland. In the area above, Eros approaches a
sleeping Psyche, while outside the garland at

4. *Cinerarium* or Grave Altar,
Roman, first to second century AD,
Pentelic marble.
Height: 30¾ inches.

the lower left and right Eros watches the
punishment of a third little love-god by
Aphrodite, a motif reminiscent of Pompeian
painting. This urn was found in a *columbarium*
on the Via Ostiense behind S. Paolo fuori le
Mura and purchased by Mrs. Gardner, again
on the advice of Richard Norton, in 1901. Six
other tombstones, wall-plaques, an altar, and a
round, inscribed shaft or *cippus* were found
with this *cinerarium*, in the same burial com-
plex. They indicate the family comprised Greek
freedmen from the Thracian or the Asia Minor
side of the Propontis, that is the Sea of Marmara
along the approaches to Byzantium. The en-
counter between Eros and the sleeping Psyche
was a comforting notion that, although the
body was reduced to ashes, the soul could be
reawakened by love.

In terms of antiquarian fame, marbles ad-
mired and copied in sketchbooks and paintings
or sculptures from Renaissance times to the
1800s, the most important work of art in Mrs.
Gardner's collection, and perhaps of its type
throughout America, is the sarcophagus with
satyrs and maenads gathering grapes (No. 5).
This large, rectangular coffin of Pentelic
marble with one long side and both ends
elaborately carved and polished, the second
long side left in a less finished state (because it
stood against a wall in the funerary chamber),
was exported from Athens to the area of Rome
in the late Severan period, between *c.* 222 to
235 AD. The occupants of the monument are
unknown, since the lid was lost or destroyed at
some date before the age of Michelangelo and
Raphael's pupils. The groups of revelling
couples on all sides, combined with the type of
lid found on other examples of this Attic
imperial sarcophagus, suggest a husband and
wife were shown on top, as if reclining at a
symposium on an elaborate couch, perhaps
attended by one or more of their children
represented as Erotes holding bunches of
grapes.

The art-historical diarist and *cicerone* of the
mid-*Cinquecento*, Ulisse Aldroandi, reported
that the Farnese-Gardner sarcophagus, as
archaeologists now know it, came from Tivoli
and was first to be seen in Rome in the
Farnesina in the 1550s. For over a quarter of a
millennium the monument ornamented the
courtyard of the Palazzo Farnese in the heart of
the city, passing finally to the Villa Sciarra. In
1898 it was purchased from the Sciarra col-
lection, again through Richard Norton. The
carving of the satyrs and maenads was es-
pecially suited to the artistic tastes of Mannerist
and Baroque Rome, providing one of the most
elegant examples of Greek imperial optic elon-
gation to have survived from ancient times.
The Farnese-Gardner sarcophagus can be con-
sidered one of the latest expressions of monu-
mental pagan sculpture used for non-historical
and decorative, funerary purposes. As such it
makes a perfect transition through the sculp-
tures of the Middle Ages at Fenway Court to
the *Cinquecento* paintings with antiquarian
flavour, like Titian's *Rape of Europa*, in the
rooms upstairs.

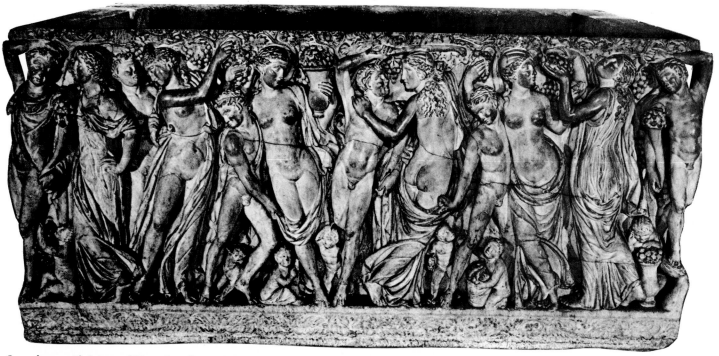

5. Sarcophagus with Satyrs and Maenads gathering Grapes, Roman, Severan period (222–235 AD). Pentelic marble. Height: 41½ inches.

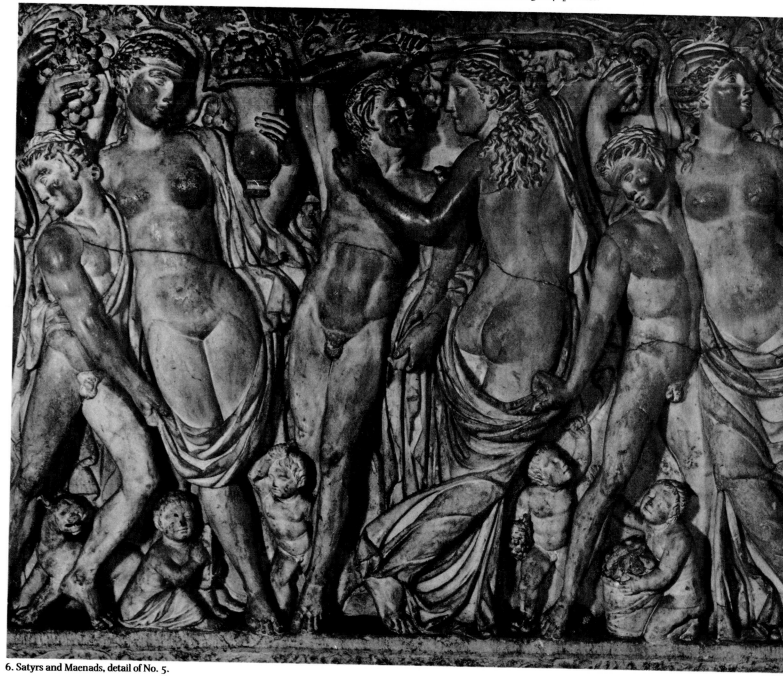

6. Satyrs and Maenads, detail of No. 5.

47

Above.
7. Sarcophagus with Flying Erotes,
Roman, *c.* 230 AD,
crystalline Greek marble.
Height: 20 inches.

8. Herm Bust of a Greek Man of Affairs or Intellect,
Graeco-Roman, copy of a work of *c.* 320–280 BC,
Pentelic marble.
Height: 20½ inches.

The sarcophagus with flying Erotes, a Roman work of about 230 AD or roughly contemporary with the bigger monument from the Farnese collection, is a much more modest carving in every respect (No. 7). By further contrast, its provenance is unrecorded. Such sarcophagi have come to be more appreciated in the past three or four decades, as Roman funerary symbolism of the last pagan century of the Empire has come to be catalogued and explored. The deceased, whose bust appears frontally in the shield in the centre, was a lady of fashion, wearing a tunic and cloak; her hair is in parallel combs and a net off the shoulders. The shield of immortality is supported on either side by flying Erotes. Two other Erotes hold attributes at the corners; an eagle supports the shield; and personifications of Earth and Ocean recline to the left and right, below. The total of four Erotes could be thought of as the four seasons regulating life on land and sea, while the eagle of apotheosis elevates the image of the deceased to a life or after-life of Olympian eternity above. Formalities of composition follow the traditions of Roman triumphal art, such as found in the historical and secondary, architectural reliefs of major arches, and the symbolism of multiple Erotes looks back to the decorative details of the cinerary urns so richly represented at Fenway Court.

Greek and Roman portraits are surprisingly few in Mrs. Gardner's collection. Such as they are they comprise mainly heads with necks and shoulders fashioned into quadrilateral bases, termed herms by the ancients after street-corner or wayside busts of Hermes. Two once-excellent Romans of the late Republic or early Empire have been set on terminal shafts to enrich a Renaissance garden and were once placed outdoors in similar fashion at the end of a vista at Fenway Court. By far the finest bust in the form of a herm is a Graeco-Roman copy of an ideal portrait of *c.* 320 to 280 BC (No. 8). Richard Norton arranged the purchase in 1901, the year of the herm's discovery near S. Saba on the Aventine. The Greek man of affairs or intellect must have graced the peristyle or garden of a Roman urban villa, since other historical or literary portraits have been found in this area. The subject is unknown, unidentified with certainty by modern critics. Vagn Poulsen and Gisela Richter debated the question in print and in lectures over two decades following the Second World War, the former favouring the Athenian fifth-century general Miltiades, and the latter, on the basis of epigraphic evidence, a herm of Miltiades in Ravenna from ancient Rome, was against this identification. Otherwise, the subject may be a philosopher, the likeness being close to those of Epicurus and Metrodorus, dominant intellects of the decades *c.* 300 or the early Hellenistic age from Greek Italy to India.

The impressive mosaic at Fenway Court was discovered at Montebello, eight miles north of Rome where the Via Tiberina joins the Via Flaminia, on the property of Cavaliere Alessandro Piacentini, and was purchased by Mrs. Gardner from the Roman antiquarians, Ditta Pio Marinangeli, in 1898 (No. 9). Andrew Oliver, Jr., then at the Metropolitan Museum of Art in New York, restudied the mosaic in connection with a companion in that institution and concluded that the delicate design in the tradition of the Pompeiian late second to third styles, that is *c.* 25 AD, was a Hadrianic revival of the early Julio-Claudian classicising composition. Brick stamps in the architectural setting showed the mosaic to have been laid on its floor in the reign of the Emperor Hadrian (117–138 AD). The building was the bathing establishment of a villa near that of Augustus' wife Livia at Primaporta, a comfortable distance from the early imperial capital. The head of Medusa dominates the centre, and various birds perch on foliate kraters at the cardinal points of a delicate system of scrolls within a heavy guilloche and fillet rectangle. Without lies the broad area of thin scroll work, the whole *ensemble* like earlier Romano-Campanian mural painting transferred to the Hadrianic floor. The technique was termed *opus vermiculatum*, with a pattern of coloured marbles in black, yellow, green and red on a background of white stone.

The saga of Mrs. Gardner's Greek and Roman antiquities can begin and end with this mosaic, for the marbles at Fenway Court were set, with considerable taste and thought, to be patterns in a larger scene. They form a picture of a band of Italophiles setting forth to create a Florentine or Roman collection of the nineteenth century (from Myron to Monticelli) in the newly-reclaimed Fens of Boston.

9. Mosaic floor pavement,
Roman, reign of Hadrian (117–138 AD),
mosaic.
Length: 16 feet 5 inches;
Width: 16 feet 3 inches.

Cornelius Vermeule
is the Curator of Classical Art
at the Museum of Fine Arts, Boston.
He is also visiting Professor of Fine Arts,
Boston College.

Photographs.
Colour A: Herbert Vose;
No. 6: Lans Christensen;
Nos. 1–5, 7 and 8: Larry Webster;
No. 9: Joseph Pratt.

Paintings in the Dutch Room

John Walsh, Jr.

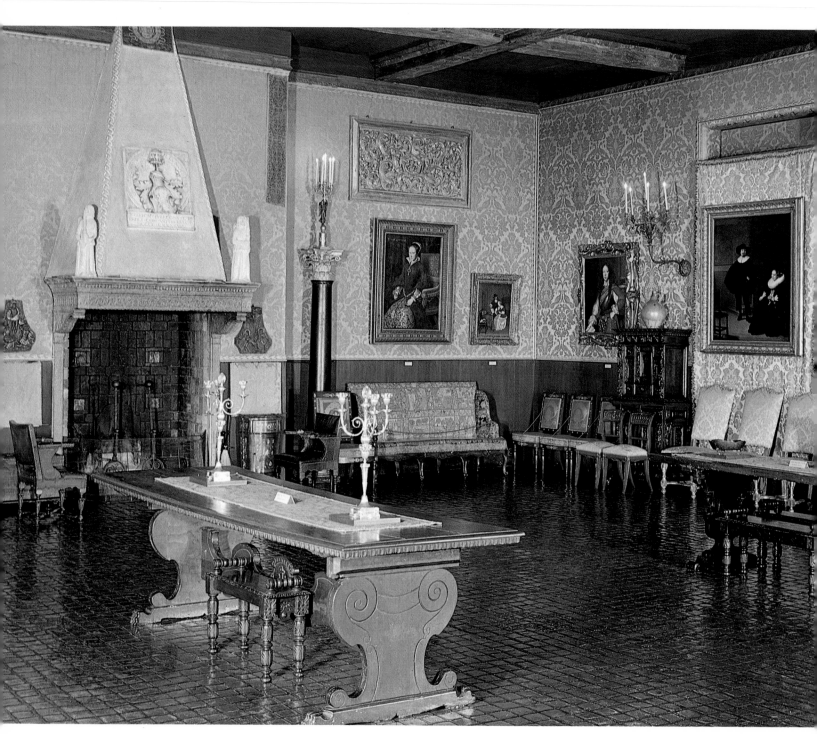

A. Dutch Room, Isabella Stewart Gardner Museum.

Mrs. Gardner's Dutch Room has the place of honour it deserves, at the head of the double flight of stairs that rises from the garden court. Hung with green damask and floored with red tiles, beneath a sixteenth-century North Italian coffered ceiling, it contains an amazing miscellany of furniture of many periods and a dozen-and-a-half European paintings, mostly northern seventeenth century. These vary in quality, but the best have long enjoyed worldwide fame.

REMBRANDT dominates the Dutch Room, Rembrandt as a youth just achieving a reputation (colour C), and Rembrandt in the flush of his early success in Amsterdam (colour B, Nos. 1 and 4). Mrs. Gardner bought all four pictures from Colnaghi's between 1896 and 1900, the years of her most energetic and inspired collecting.

Rembrandt's *Self-portrait* in fancy dress of *c.* 1629 is the most imposing of his youthful self-portraits (colour C). After experimenting in the mirror with grimaces, smiles, and moody self-absorption, and having recorded his features in small, closely-cropped images in various media, Rembrandt took up a large panel and painted a grander, steadier presence. From his stock of props he drew a plumed velvet cap, a green-gray robe, and a finely woven neckcloth with subtle silver stripes. The artist also granted himself a splendid gold chain of the type he and other men in fancy dress wear so conspicuously in his pictures of the 1630s. Light falls in a pool on his face and shoulder with potent effect, but the penumbra is subtly varied in tone. Shadow masks the eyes, as it does in the earlier self-portraits in Amsterdam and Munich, seeming to veil whatever thoughts the eyes might otherwise permit us to divine, and the slightly raised eyebrows and parted lips give the face an alert, even expectant air.

When Rembrandt began painting portraits in Amsterdam in 1631, this novel combination of exquisite finish and dramatic conception made his reputation. The double-portrait of 1633 (colour B) must have satisfied the taste for meticulous detail nurtured by older Amsterdam painters such as Nicolaes Eliasz and Thomas de Keyser – the woman's embroidered stomacher is painted with breathtaking skill – but it would also have astonished the audience with its theatrical lighting and its air of expectancy. During the course of a recent cleaning it became evident that a good many changes of design lay under the surface; x-rays show that in between the parents Rembrandt first included a little boy brandishing a stick over his head (No. 5). If the forms on the floor were more legible in the x-ray we would probably know what Rembrandt intended: the dark shape at the left might be a dog, such as can be found in a number of Dutch family scenes, which the child might be threatening, playfully or not; or the child might be whipping a top, the toy that served in literature of Rembrandt's time as an emblem for the upbringing of

1. REMBRANDT HARMENSZ. VAN RIJN. *Storm on the Sea of Galilee*, signed and dated '1633', 63 × 50 inches.

2. SIMON DE VLIEGER. *Storm on the Sea of Galilee*. *Kunstsammlung der Universität, Göttingen.*

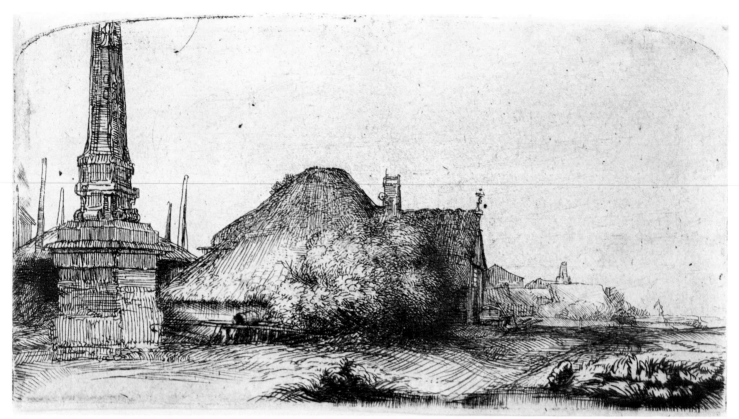

3. REMBRANDT HARMENSZ. VAN RIJN. *The Obelisk at Halfweg*, etching. *Museum of Fine Arts, Boston.*

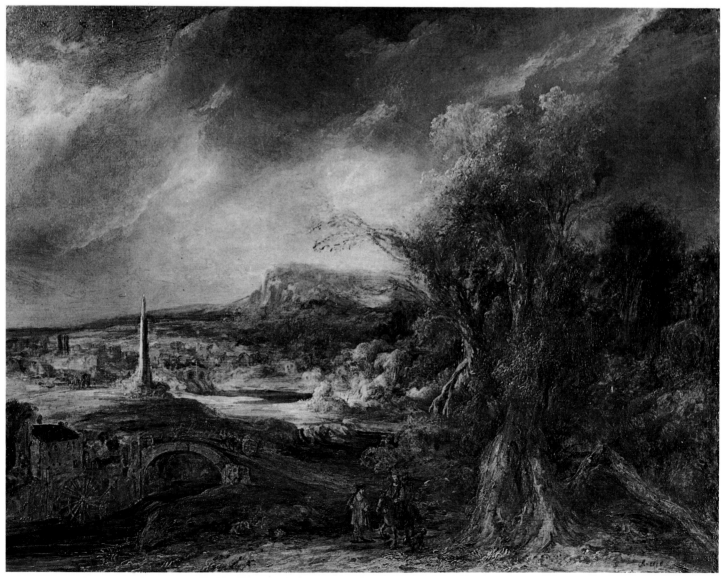

4. REMBRANDT HARMENSZ. VAN RIJN. *The Obelisk*, signed and dated '*1638*', $21\frac{3}{4} \times 28$ inches.

children. In any event the carefully-calculated intervals of the finished picture are the result of a curious process of subtraction from a composition that originally had far more physical action, like his portrait of the *Shipbuilder and his Wife* (H.M. the Queen) of the same year.

If the double-portrait vibrates with inner activity, the other picture of 1633, the *Storm on the Sea of Galilee*, explodes with violent action (No. 1). Frightened disciples awaken Christ in the midst of a storm, while others try to reduce sail as their boat slams into a wave and takes a torrent of water aboard. Each of the men wears a vivid expression, whether struggling, imploring, cringing, trusting, or vomiting. This is the very strength of characterisation Constantijn Huygens praised in the *Judas returning the Thirty Pieces of Silver* of four years earlier (Normanby Collection, Mulgrave, Yorkshire), pointing to the appropriateness of gestures and expression in Rembrandt's highly dramatic history paintings. Rembrandt's colour is anything but violent – the pinks, greens and lemon yellows of the disciples' costumes strike an almost gay note.

Rembrandt's only marine painting was executed at a time when sea-painting was growing in popularity, given impetus by a second generation of specialists, particularly Jan Porcellis, Simon de Vlieger, and Bonaventura Peeters, whose work he knew – he owned six pictures by Porcellis. We need not imagine him actually observing storms at sea in order to paint this picture, but looking at other pictures: for the general composition, Maerten de Vos' engraving of fifty years earlier showing Jonah being thrown overboard, and for the wispy gray water, such paintings by Bonaventura Peeters as the *Storm* of 1632 in Prague (Národní Galerie No. 4486). The ship is a strange pastiche of implausible parts convincingly painted, especially the stumpy single-masted rig, which twists powerfully to impart a great upward spiral to the composition. No pedantic realist, Rembrandt painted a bowsprit and then eliminated it, as one of many *pentimenti* shows. When Simon de Vlieger painted his version of the subject four years later (No. 2) he adopted Rembrandt's *mis-en-scène*, turned the ship bows-on, and studiously corrected Rembrandt's nautical lapses – but the result is far less powerful narrative drama.

The Obelisk is one of the most impressive of the small group of painted landscapes by Rembrandt (No. 4). Nearly all these pictures

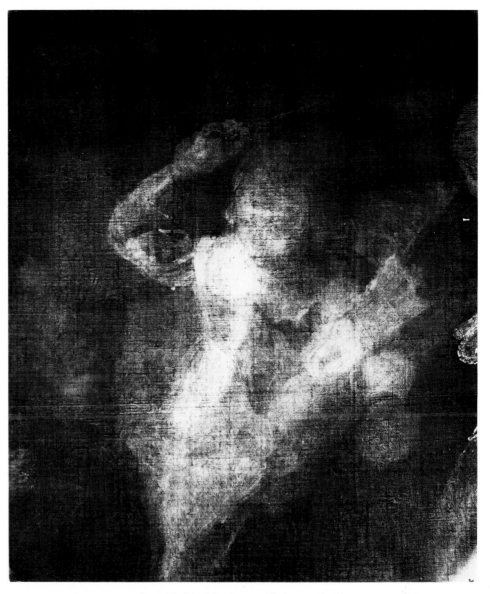

5. REMBRANDT HARMENSZ. VAN RIJN. *A Lady and Gentleman in Black*, x-ray detail.

have an element of fantasy and many, like this one, show wholly imaginary landscapes summoned up by Rembrandt's powerful imagination out of impressions gathered from other men's art, especially Hercules Seghers'. He also observed nature, especially the play of light and shade induced by vast stormy skies, and occasionally included motifs from the Dutch countryside. Here a falconer and a rider move forward past a thick tangle of woods, legible at last after a recent cleaning. A vast valley stretches beyond them, cut by a river that flows from arched sluices outside a town in the background towards a bridge and a water mill in the foreground. On a rise above the river, stands a dramatically lit obelisk, a stupendous version of the monuments that were set up to serve as milestones in Rembrandt's Holland (No. 3). The traditional associations of obelisks with eternity may have played a part in Rembrandt's decision to include it; the effect is to enoble and historicise the landscape.

Between the two Rembrandts of 1633, in the centre of the wall, hangs Rubens' arresting

portrait of the *Earl of Arundel* (No. 6), the collector whom Walpole called 'the father of *vertu* in England'. Arrayed as Earl Marshal of England, he wears armour and the small badge of the Order of the Garter, and holds the gold baton of his office. His head is one of Rubens' most commanding characterisations, alive with energy, yet calm with self-assurance. Though not depending on any single prototype of Titian, he evokes memories of such disparate works as the so-called *Ariosto* (National Gallery, London) and the three-quarter length portrait in armour of *Francesco I della Rovere* (Uffizi, Florence). Rubens pays tribute to his great predecessor as painter to the princes of Europe by adopting a Titianesque format and fluidly painted, luminous flesh-tones. Recent writers have been inclined to date the portrait after Rubens' return to Antwerp in 1630. A painted half-length version exists in the National Portrait Gallery, London, which is presumably earlier than the Gardner painting, and a splendid brush drawing for the whole composition is now in Williamstown (No. 7).

B. REMBRANDT HARMENSZ. VAN RIJN. *A Lady and Gentleman in Black*, signed and dated '*1633*', $51\frac{3}{4} \times 42$ inches.

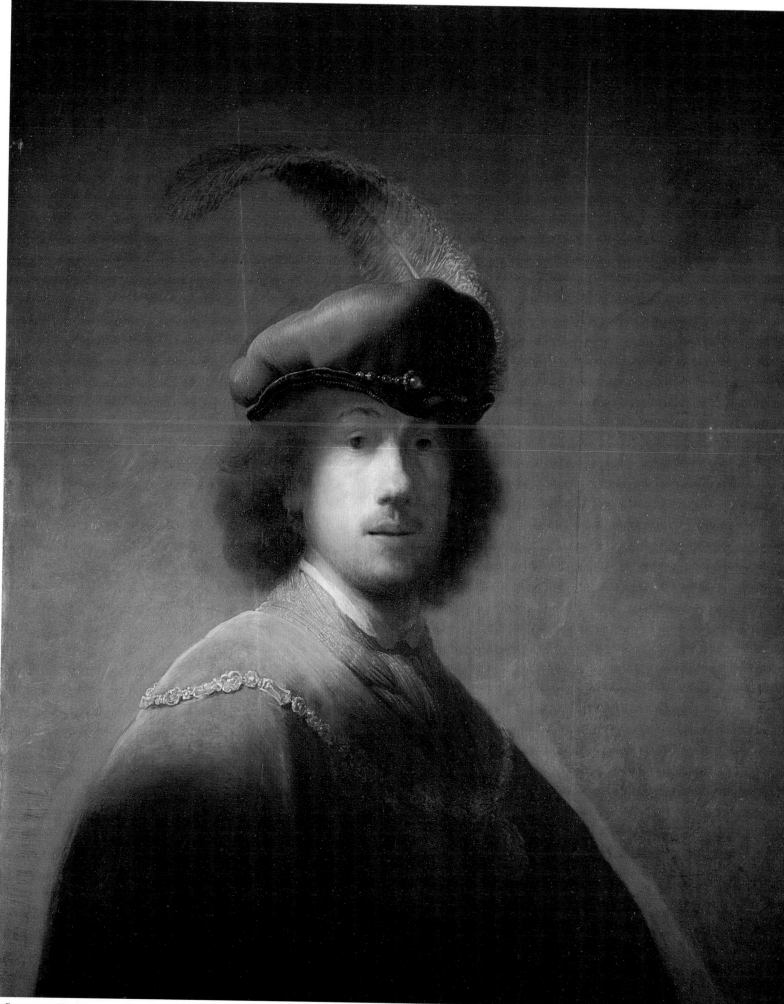

C. REMBRANDT HARMENSZ. VAN RIJN. *Self-portrait*, signed in monogram 'RHL'. 35 × 29 inches.

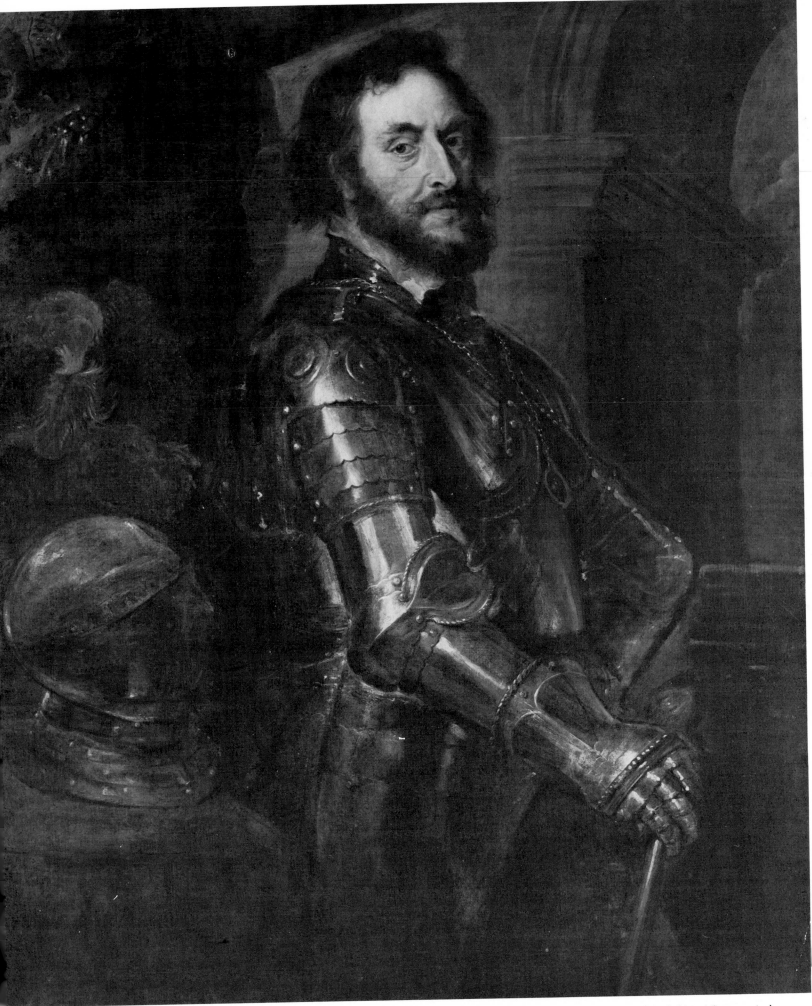

6. PETER PAUL RUBENS. *Thomas Howard, Earl of Arundel.* 54 × 45 inches.

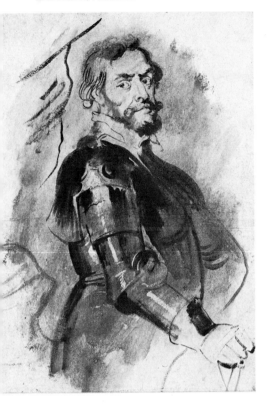

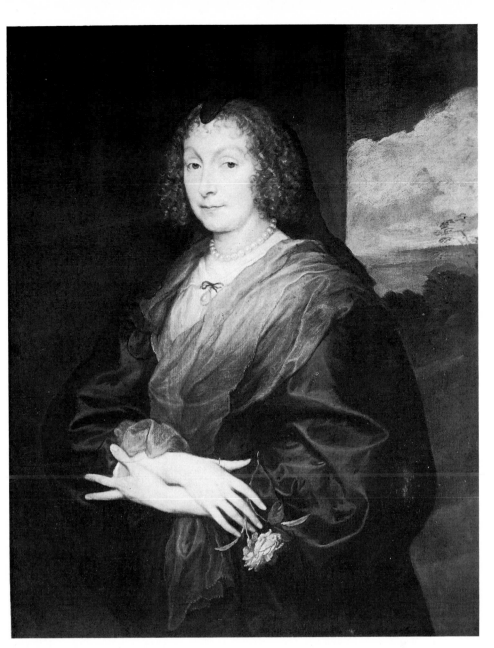

8. ANTHONY VAN DYCK. *A Lady with a Rose,* 39 × 30½ inches.

The fine head and breastplate are substantially as Rubens painted them, but most of the highlights of the armour cannot be by him. They are exaggerated, clumsy and pedantic compared to the beautiful chain in this picture or the suave treatment of light on similar armour in Rubens' portrait of Archduke Ferdinand of the same period (Ringling Museum, Sarasota). A recent examination revealed that the painting was extensively overpainted at a later date, very likely in the eighteenth or early nineteenth century. There are indications of Rubens' own summary blocking out of forms, for instance in Arundel's left elbow and in the column base. The helmet, feathers, curtain and table also may have been blocked out by Rubens (traces of white paint can still be seen under the dull blue mass of the feathers), but the portrait was left unfinished and worked up by another hand. In the most recent cleaning overpaint was not removed but its effect was made less assertive.

On an easel by the west windows hangs *The Concert* by Vermeer (colour D). The trio is pushed to the back of a spacious room, the foreground dominated by a large table that holds music and a viol. A heavy Oriental rug partly hides a *viola di gamba* on the floor. One woman sings, accompanied by a lute and clavichord; behind them, hanging at carefully calculated intervals, are a landscape and a scene of another threesome with a lute. The latter is very familiar – Dirck van Baburen's *Procuress* of 1622 which Vermeer evidently owned and which he painted in the background (differently framed) in several of his pictures. As music-making is often associated with love in Dutch paintings, and as houses of pleasure were evidently furnished with elegance and taste, it is tempting to see Vermeer's scene as a latter-day version of the trio treated more coarsely by Baburen, and all the more seductive for its extreme refinement.

The paint surface has suffered, and at some time in the past the blue skirt and the jacket of the singer became discoloured. Recent cleaning and restoration have done much to recover Vermeer's clarity and tonal balance.

Van Dyck's *A Lady with a Rose* (No. 8) was evidently painted in his last years. Although it does not rise to the artist's highest standard of execution, the portrait uses an attractive idea to good effect: the arms are folded in a manner reminiscent of Rubens' most personal portraits of women, *Susanna Lunden* (National Gallery, London) and *Isabella Brant* (Uffizi, Florence), while from the fingers of one hand dangles the rose that is so often the attribute of Van Dyck's English women, with its associations of love, beauty, and the brevity of both.

To these northern paintings, Mrs. Gardner added one Spanish picture in 1910, the life-size portrait of *A Doctor of Law* by Zurbarán (colour E). The young lawyer wears the academic costume of the University of Salamanca, a brown robe, a bright red hood, and a green cap; he looks out steadily without any very remarkable expression to challenge our curiosity about him. The face has the sure, smooth planes we associate with Zurbarán, while the hand on the chair back has the soft delicacy and broken surface of a hand by Velázquez. In fact the strong impact of Velázquez on this portrait, both in composition and technique, has been much discussed, and consensus places it very late in Zurbarán's career, 1658–1660.

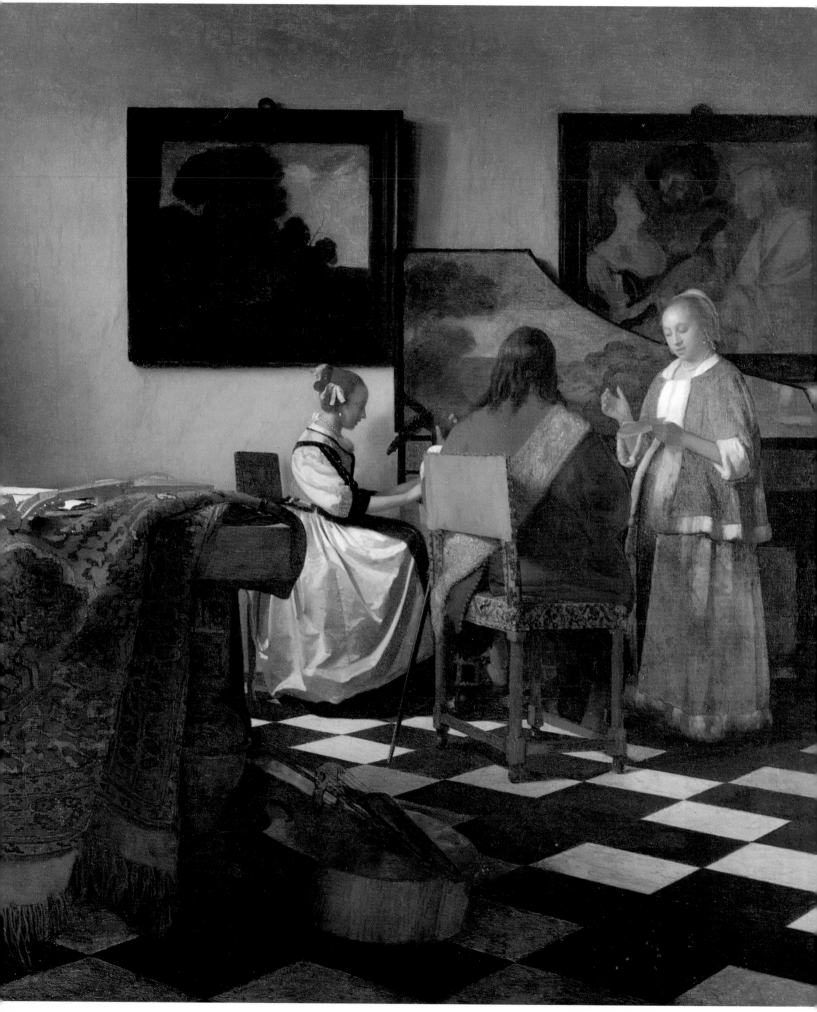

D. JOANNES VERMEER. *The Concert*, $27\frac{1}{4} \times 24$ inches.

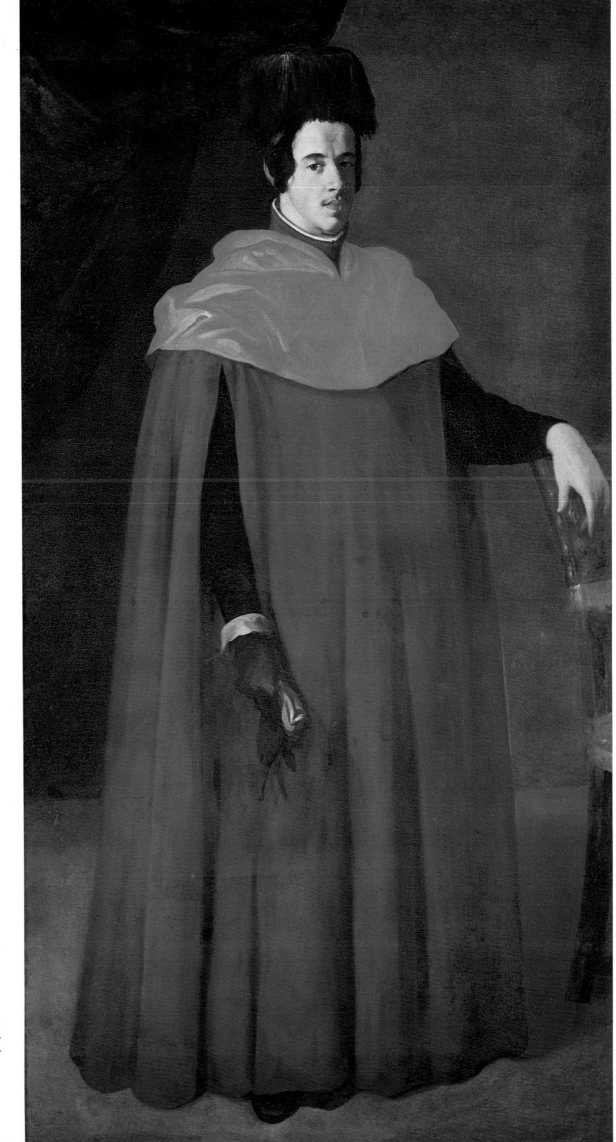

E. Francisco de Zurbarán.
A Doctor of Law,
$76\frac{1}{4} \times 40\frac{1}{2}$ inches.

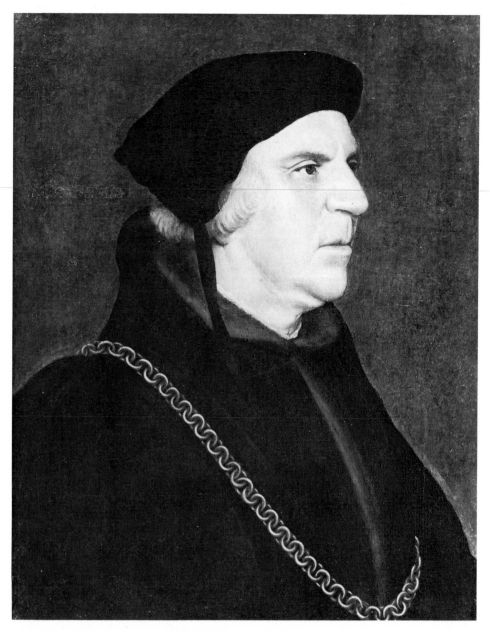

9. HANS HOLBEIN.
Sir William Butts, MD.,
$18 \times 14\frac{1}{4}$ inches.

Mrs. Gardner fared better with seventeenth-century northern paintings than she did with earlier ones, and the walls of the Dutch Room carry several sixteenth-century works whose attributions have proved too optimistic. Not, however, Holbein's distinguished, and only, pair of husband-and-wife portraits, which hang there (Nos. 9 and 10). Sir William Butts, physician to Henry VIII, and his wife Lady Margaret are represented. Butts appears as the King's confidant in Shakespeare's Henry VIII (V, 2), in which he observes Cranmer reduced to the indignity of waiting for an audience before the Council, and reports it to the King. In the same year, 1543, Holbein also painted Butts in the Barber's Hall group portrait. A portrait of his son William Butts the Younger dating from that year has, by unrelated circumstances, also come to Boston (Museum of Fine Arts), although extensively repainted and reattributed to John Bettes. Holbein's portrait of Sir William is too worn to give more than a suggestion of its original strength and sympathy, but his wife's has fared better. The only surviving portrait of an older woman by Holbein, it shows the artist's customary large-

ness of design and fineness of modelling and detail.

BIBLIOGRAPHY
Earlier literature on all the paintings is summarised in Philip Hendy, 'European and American Paintings in the Isabella Stewart Gardner Museum' (Boston, 1974). The more significant recent publications are noted below.

For the Rembrandt double-portrait, John Walsh, Jr., 'Child's Play in Rembrandt's Lady and Gentleman in Black', *Fenway Court*, 1976, pp. 1–7, where the x-rays and the place of the picture in Rembrandt's work are discussed at greater length.

For the Vermeer, Ernst Günther Grimme, 'Jan Vermeer van Delft', Cologne, 1974, pp. 52, 70, fig. 10, and p. 104, no. 14; and Albert Blankert (with R. Ruurs and W. L. van de Watering), 'Johannes Vermeer', Utrecht/Antwerp, 1975, pp. 41, 66, 151, no. 17, pl. 17, where a date of 1664 is proposed, and a new owner (1780) has been found.

For the Zurbarán, Jonathan Brown, 'Francisco de Zurbarán', New York, 1973, pp. 47–48, pl. 45.

For the authorship of the Holbein portrait of *William Butts the Younger*, Roy Strong, 'The English Icon', London, 1969, and John Fletcher, 'What Wooden Panels Can Reveal', *The Conservator* 1 (1977), p. 16.

I am indebted to Gabrielle Kopelman, conservator of paintings at the Museum, for information about the treatment of the paintings and many valuable suggestions, and to Egbert Haverkamp-Begemann for advice.

Photographs.
Colour B–E, Nos. 6, 9 and 10: Herbert Vose;
Colour A, Nos. 1 and 8: Joseph Pratt.

John Walsh, Jr.
is Curator of Paintings
at the Museum of
Fine Arts, Boston.

10. HANS HOLBEIN.
Lady Butts,
$18 \times 14\frac{1}{2}$ inches.

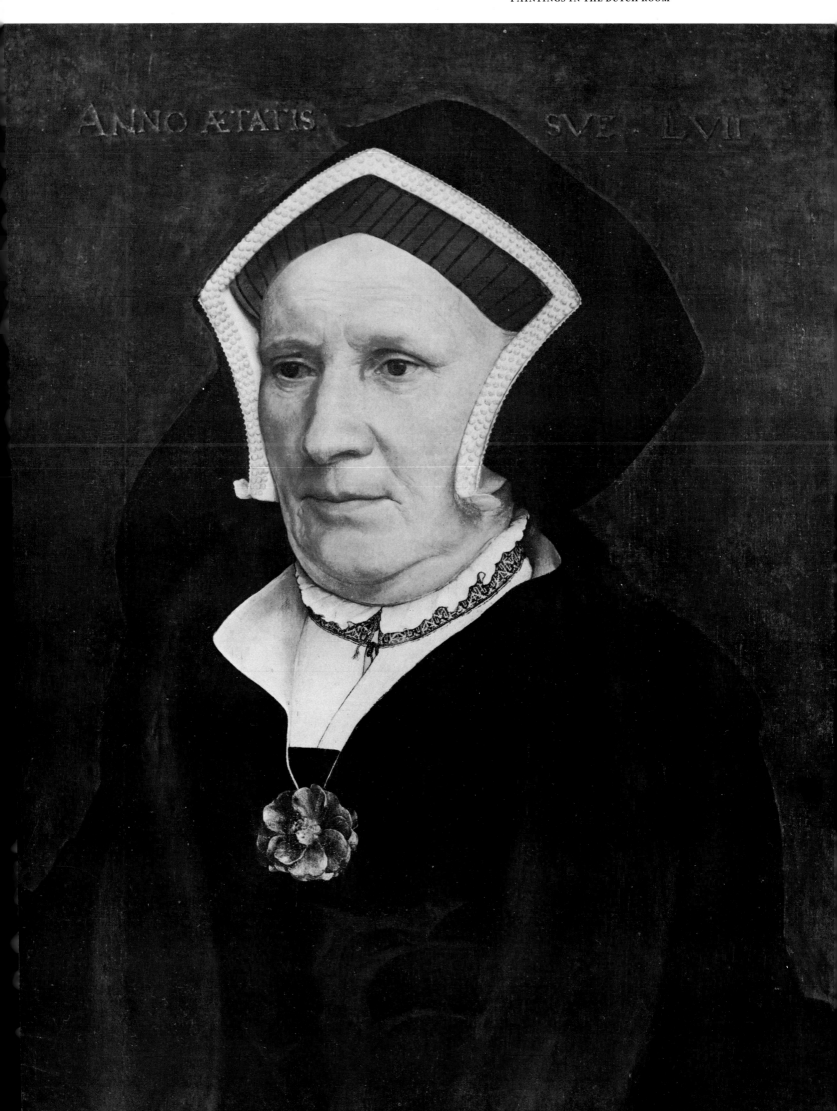

ANNO ÆTATIS SVE · LVII

Benvenuto Cellini's bronze bust of Bindo Altoviti

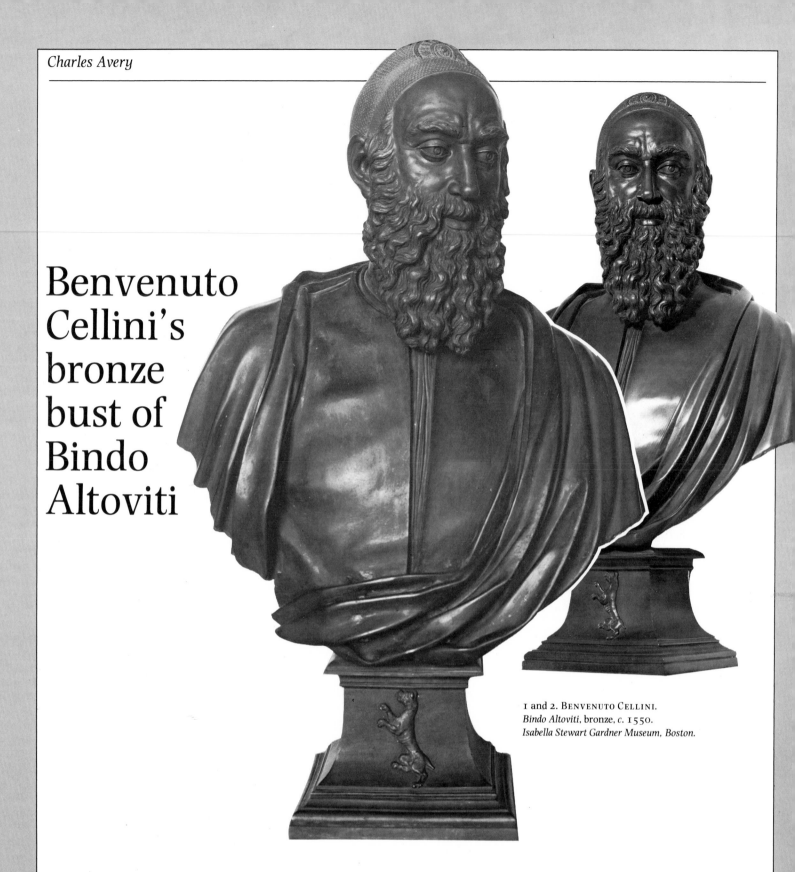

1 and 2. BENVENUTO CELLINI.
Bindo Altoviti, bronze, *c.* 1550.
Isabella Stewart Gardner Museum, Boston.

Trained as a goldsmith in Florence, Benvenuto Cellini (1500–1571) worked in Rome from 1519 until 1540, with visits to Florence, Venice and France. Seals, medals, cap-badges and jewels for noblemen and prelates were his speciality: like most of his generation, he was influenced by Michelangelo, but tended towards Mannerist elaboration of detail. From 1540–1545 he was employed by Francis I of France and extended his range into sculpture on a large scale. Cellini's masterpiece as a goldsmith was a salt cellar (Kunsthistorisches Museum, Vienna) begun in Italy and finished for Francis I. It is the epitome of a Mannerist work of art: intricate in design, complex in theme, and brilliant in technique. Under suspicion of embezzlement, Cellini returned to Florence and executed for Cosimo I de' Medici a bronze statue of *Perseus and Medusa* for the Piazza della Signoria, unveiled in 1554. At the same time he produced a colossal bust in bronze of Cosimo, originally parcel-gilt and enamelled, which is the most dynamic portrait of the century. By 1560, Cellini's popularity was waning and he turned to writing – his 'Autobiography' (1558–1562) and 'Treatises on Goldsmithing and Sculpture' (1565) – owing to which we are better informed about him and his art than about any other Renaissance artist.